Painting Flowers

THE VAN WYK WAY

Helen Van Wyk

Art Instruction Associates, Rockport, Massachusetts
Distributed by North Light Books, Cincinnati, Ohio

Acknowledgment

In order to be able to produce this revised edition of Helen Van Wyk's flower painting classic, we've had to come up with new editorial matter, including new color art. We were fortunate to be able to locate never-before published paintings by Helen, which completed only part of our job. There were other illustrations and step-by-step progressions still to be done. We found, from among the group that Helen called her Tuesday Ladies, three painters to help us accomplish this task. At this time, we would like to introduce them to you, along with the identifying initials that appear on the paintings for which each was responsible. The painters are: Eleanor Driscoll (ED), Lorraine DeGroot Stevens (LDG), and Laura Elkins Stover (LES). There is biographical material about each of these women in the chapter, The Tuesday Ladies — A Comment and Tribute (page 7).

PAINTING FLOWERS The Van Wyk Way
by Helen Van Wyk

Copyright © 1997 by Art Instruction Associates
Rockport, Massachusetts 01966 U.S.A.

Revised from original version of PAINTING FLOWERS The Van Wyk Way,
Published by Art Instruction Associates, 1981.

Published by Art Instruction Associates
2 Briarstone Road, Rockport, Massachusetts 01966

ISBN 0-929552-12-1

99 98 97 5 4 3 2 1

Distributed to the book trade and art trade in the U.S. by
North Light Books, an imprint of F&W Publications
1507 Dana Avenue, Cincinnati, Ohio 45207
Telephone: (513) 531-2222, (800) 289-0963

Edited by Herb Rogoff

Art Direction by Bridges Design

Design by Laura Herrmann

Indexing by Ann Fleury

Project coordinated by Design Books International
5562 Golf Pointe Drive, Sarasota, FL 34243

Printed and Bound in Singapore

Metric Conversion Chart

To Convert	To	Multiply By
Inches	Centimeters	2.54
Centimeters	Inches	.4
Feet	Centimeters	30.5
Centimeters	Feet	0.03
Yards	Meters	0.9
Meters	Yards	1.1
Sq. Inches	Sq. Centimeters	6.45
Sq. Centimeters	Sq. Inches	0.16
Sq. Feet	Sq. Meters	0.09
Sq. Meters	Sq. Feet	10.8
Sq. Yards	Sq. Meters	.08
Sq. Meters	Sq. Yards	1.2
Pounds	Kilograms	0.45
Kilograms	Pounds	2.2
Ounces	Grams	28.4
Grams	Ounces	0.04

REVISED EDITION

Painting Flowers

THE VAN WYK WAY

Helen Van Wyk

About
Helen Van Wyk

Started painting at twelve...

Won first top award at seventeen...

Taught first class at eighteen...

Exhibited at National Academy and many others...

Demonstrated painting and lectured in
more than 300 cities...

Invited to teach by organizations in
twenty-two cities in ten states...

Paintings in collections all over America and Europe...

Created the magazines "Palette Talk" in 1967
and "Alla Prima" in 1991...

Writer and star of six home video presentations...

Star of PBS-TV series "Welcome to My Studio," 1989-1993.

Contents

Introduction

The study of painting is not learning to paint trees or faces or flowers. The study of painting is learning to use paint in such a way that it can record a vast choice of subject matter. Regardless of what the subject matter is the painting process is always the same. Simply stated, painting is using a substance that can record shapes of contrasting colors. These shapes can be abstract ones or extremely realistic. The interpretation that the paint makes of any subject is a direct result of the painter's choice and skill.

There are many things a student must learn that will influence his painting skill. The student should train himself to observe carefully rather than to look casually. He must discipline himself to have practical working habits. He must understand the principles of painting and learn to adjust and use them on any subject. He must be able to analyze his subjects, making him aware of their characteristics. Finally, the student of painting must recognize the capabilities and limitations of his painting materials.

In order to alert you to the significance of each of these factors, and how they apply to painting flowers, I've dissected the entire painting process: (1) defining the painting components; (2) describing painting materials and their uses; (3) putting the components into practice; (4) demonstrating painting procedures. I hope that this presentation will help you to evaluate your way of painting and, accordingly, make your flower paintings more successful.

Helen Van Wyk, Rockport, MA

A Comment and Tribute

The Tuesday Ladies

By Herb Rogoff

In the northeast corner of Massachusetts, just forty miles north of Boston, lies a piece of real estate that juts out into the Atlantic Ocean. It's the other cape in Massachusetts, the one few out-of-staters had ever heard of. It's Cape Ann.

Those who have traveled there know of its cooler temperatures, making the region desirable during the summer months. They also delight in the plentiful supply of fresh seafood, principally lobster, available alive and kicking, or red hot, bright red, fresh out of the boiling pots of restaurants and lobster pools in Rockport and Gloucester, the two major communities on Cape Ann.

Other attractions to Cape Ann are the shops, thronged daily with humanity during the peak months of July, August and September, but past Labor Day, down to weekend jaunts until the last shopping day before Christmas.

Included among the shops are scores and scores of art galleries that offer visitors paintings in all media, all subject matter, all prices and almost all painted realistically.

It was the town of Rockport, a hotbed of art activity, that attracted Helen Van Wyk in 1968, where she planned to paint, teach and enjoy the fruits of those arduous labors. While still back in her New Jersey home, Helen had carefully had the Rockport zoning regulations checked well before even one nail had been driven home in the house she had already had an architect friend design for her. She found that the way was clear for

her to conduct classes from her soon-to-be-built residence and studio on Briarstone Road.

For the previous nine years, Helen had traveled all over the country to give demonstrations and also to conduct painting workshops. In the process, she had amassed a list of people who were eager to be taught by her in the dynamic style she had displayed for them earlier in their own towns, in their own art associations. These students were to be the core of her classes in Rockport.

They didn't disappoint her; they came from far and wide, combining vacation with study, occupying the various guest houses and hotels, frequenting the restaurants of Rockport and (if a drink with dinner was desired) nearby Gloucester. Helen taught a new string of students each week, culminating the concentrated study with a two-hour demonstration each Friday morning, open, too, incidentally, to the public at large. The Friday demonstrations, starting every June right through to October, became a Rockport institution, continuing for the next twenty-five years in front of capacity audiences.

The winter was a different matter. In the beginning, she was better known throughout the rest of the country than in her own backyard. However, after just a few demonstrations for art clubs in the vicinity of Rockport, she was able to recruit a roster of students. One class in particular was filtered through to a dozen hard-working, conscientious women who met every Tuesday morning. They became the group

that Helen dubbed her "Tuesday Ladies." Even though this designation may have grated on some feminists' ears, it sounded right to Helen and to her "ladies."

The group first met in 1970 and continued to paint together every Tuesday from October to the end of May until 1993 with basically the same cast of characters. (We have Laura Stover, a member of the group, to thank for her painting of the Tuesday Ladies, shown below.)

Helen's ladies traveled to class from as close as a few streets away in Rockport (Virginia Merrill, the oldest of the bunch) to Arlington, a one-hour drive (Lorraine Stevens) and Westwood, fifteen minutes farther than Arlington (Betty Galbraith) to Spencer, some 85 miles from Rockport (Jeanette Nadreau). The bulk of her student body, however, came from Danvers, nineteen miles away: Jean Lewis and Louise Demeter arrived in one car; also from Danvers,

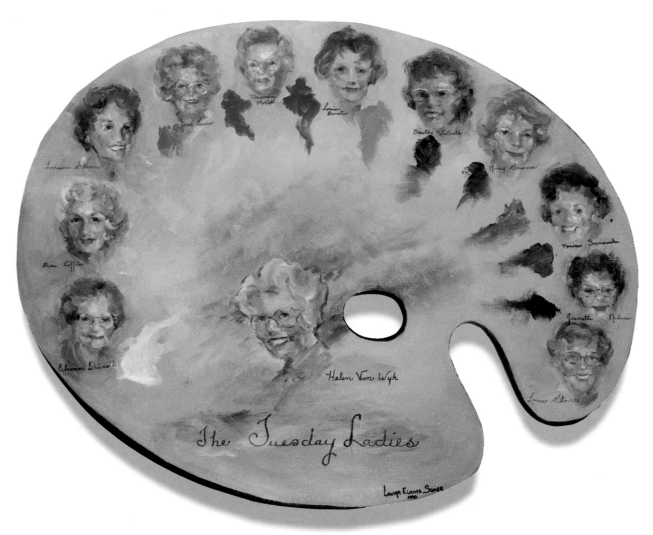

❧ *The Tuesday Ladies*

The Tuesday Ladies, painted by Laura Stover in 1990, pictures a likeness of each member at that time. Starting at the lower left and reading clockwise are: Eleanor Driscoll, Rose Coffin, Lorraine Stevens, Jean Lewis, Virginia Merrill, Louise Demeter, Dorothy Colbeth, Nancy Granese, Norma Sosnowski, Jeanette Nadreau and Laura Stover. In the center, we see Helen Van Wyk, the leader and motivating force of the painting group, who, twenty years earlier, had capriciously given them their name.

coming together, were sisters Norma Sosnowski and Nancy Granese. Rounding out the "Danvers connection" were Rose Coffin, Dot Colbeth and Eleanor Driscoll. Finally, from Topsfield, a town that borders Danvers, Laura Stover.

Every Tuesday, I would move my car to a spot that would leave me free to come and go because once the Tuesday Ladies arrived their cars were consolidated in one area, around the student studio, which was, in reality, a garage. A garage, yes, but one that was unlike any that anyone had ever seen. Its walls were covered, just like a block of postage stamps, from one corner to the other, from ceiling to floor, with portraits that Helen had painted over the years in demonstrations in various cities and towns in America. Interspersed were portraits of family and friends, a number of self portraits and many of me, who Helen claimed was her favorite model.

It was in this setting that the Tuesday Ladies would begin to paint at nine, or shortly thereafter. Coffee, tea and some pastry that one of the ladies had baked were set up atop the washing machine in the utility room that abutted the studio. However, nothing in the entire house was off limits to any of the students who, with coffee cup in hand, would wander through Helen's studio, ogling the latest work on her easel; they looked, too, at Helen's vast store of still life objects, hoping to find one to borrow to paint at home.

Helen's involvement always started the day before, setting up still life subject matter and arranging the lighting and easels in such a way to accommodate each student. Helen had few rules, but was dictatorial about two of them: never move the easels, and all purses and other personal items were to be stored in the adjacent room. The studio was now set for the business at hand, grappling with the principles that would produce three-dimensional reality on a two-dimensional surface.

For the next three hours, the ladies would work diligently if not frenetically. Some bits of chatter would sneak in despite Helen's disapproval. "Save the gab for lunch," she would admonish her students. Then, lunchtime. Each would fetch her sandwich, brought from home and stored in the studio refrigerator, and grab coffee or tea from the washing-machine server. Then, depending upon the the kind of day it was — sunny or overcast — the group would meet either on the sun porch (sunny day, naturally) or at the dining room table, which was set up to serve the large group. The conversation usually started with talk of kids and grandkids then segue to a critique of the previous week's television fare, then move to the "jokes-just-heard" department and culminate in art talk: museum shows, art association doings, to individual accomplishments such as awards won, paintings sold.

Lunch over, back to the easels, but this time with much reduced enthusiasm. Those ladies who traveled the farthest would leave the earliest. Little by little, the class would whittle down to a dwindling few. Once alone, Helen would come into the kitchen for a glass of wine and we would both talk over the day just completed before she would head back to the studio for the inescapable clean-up. The next week, the ladies would meet again. New project, new lesson, same chatter.

When this revised edition of Painting Flowers was in the planning stage, I was faced with a dilemma regarding up-dated illustrations. I filled in what I could from available, unpublished color photos of Helen's flower paintings but I needed additional material that unfortunately was no longer possible to get from Helen. I thought of the Tuesday Ladies, but, obviously, using all of them would have been too cumbersome — a logistical nightmare. I selected three ladies whom I felt could do justice to the project. After twenty-five years under Helen's "mother-hen" guidance, I was confident that they could provide the needed paintings that would benefit the book. The Tuesday Ladies I am writing of are Eleanor

Driscoll, Lorraine DeGroot Stevens and Laura Elkins Stover. You will see their work sprinkled throughout this book identified by the initials ED, LDG, and LES. What follows are their recollections of how they met Helen and the affect she has had on each one. We present these artists to you with our heartfelt gratitude for their important contributions.

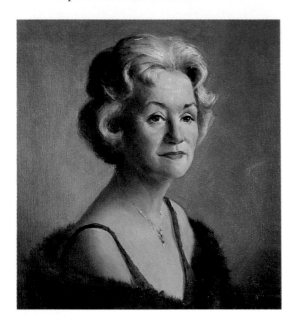

Eleanor Driscoll

I first met Helen when I attended a demonstration in her gallery in 1969, just one year after Helen's move to Rockport. Up to that point, I was mostly self taught but had seen enough demonstrations to know that what Helen had done that day was something I had never before experienced. And I had never heard the principles of painting explained in the simple, logical way that she presented to her audience.

After the program, I asked Helen if she could possibly accept me as a student since, with most of the kids grown, responsibilities reduced and more time available, I was now prepared to approach my painting far more seriously. She said yes. From that day on, not only did I enjoy working with the most fascinating teacher in the area, but I also gained a loving, lifelong friend.

Helen's style of painting was exactly what I had been searching for. Here was a marvelous teacher, painting in the style of the revered Old Masters who could articulate every phase of the procedure. In no time at all, more students joined us and from this beginning the Tuesday Ladies evolved. We painted together every week (Tuesday, of course) and traveled from time to time to museums in Boston, New York, Washington and even Europe, studying the works of the Masters, guided by our own resident Master.

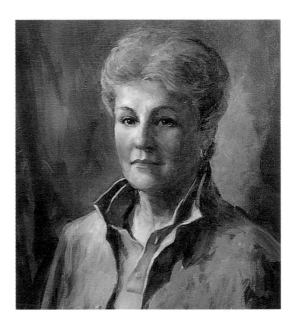

Lorraine DeGroot Stevens

Since childhood, I had been interested in drawing and painting. My high school had a fine arts college course, and for that I was fortunate, leading me to go on to the Museum of Fine Arts School in Boston. But marriage and children (three) put my budding painting career on the back burner to be awakened years later, once the children were old enough. I studied with various artists in my area but yearned to paint in the manner of the Old Masters, not a popular style at that time.

A friend of my mother's, a nun, recommended that I visit Helen Van Wyk in Rockport. As soon as I saw Helen's work I was determined to

study with her. This was back in 1968, not long after she relocated to Rockport, thus making me one of her first students in her new home.

I had found my niche. I wanted sincere criticism and enjoyed the way Helen was so willing to share all of her knowledge with students. I was so impressed that I took a few of my friends along to her studio to join the class. Helen would teach beginners as well as more experienced painters.

After several years, Helen told me that I should leave class and paint more at home to develop as an artist. I appreciated her concern but I told her that I needed the group and the camaraderie that it gave rise to. I stayed and soon after that the Tuesday Ladies were born. We've been together for almost twenty-five years until it ended with Helen becoming ill.

Even though Helen was very ill herself, when I went through two cancer episodes, Helen was my biggest supporter. She was a wonderful friend and teacher and an inspiration in so many ways.

I have been teaching in my own right for more then twenty years, continuing to paint still lifes, flowers and portraits (with an angel on my shoulder). I have won many awards and have paintings in a number of private and public collections, principally the University of Maine. I paint under my maiden name, DeGroot, and use it in honor of the Dutch Masters and also in honor of my favorite Dutch painter, Helen Van Wyk.

Eleanor Driscoll (far left) is shown in a detail of a portrait by Helen Van Wyk, painted at a demonstration for a portrait class.

Lorraine DeGroot Stevens (left) painted this self portrait as a homework assignment over a summer recess from the Tuesday Ladies sessions.

Laura Elkins Stover's self portrait (above right) was painted expressly for this revised edition of Painting Flowers the Van Wyk Way.

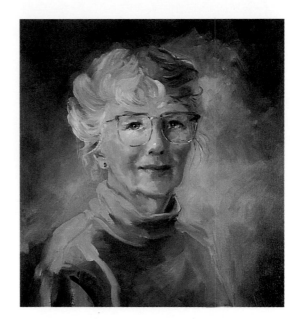

Laura Elkins Stover

In early 1975, I attended my first Helen Van Wyk painting demonstration in her home and studio in Rockport. I was completely in awe of her painting ability, her enthusiastic presentation, and the amount of instruction that one demonstration contained. It was a revelation to me, and from that moment on I was dedicated to becoming a better painter.

That summer, I attended a workshop, there in her studio, where she stressed valuable painting principles, painting what the light does to a subject, and much, much more; I was truly inspired. Shortly after the workshop, I was accepted as a regular weekly student and eventually reached the status of "Tuesday Lady," an association over many years with Helen and the other "ladies" that proved to be very heartwarming and important to me. I would never have been a painter of any sort were it not for Helen's encouragement and leadership; she challenged me at every turn. As a result, my skills grew and blossomed.

Helen Van Wyk was an inspiration. I am fortunate to have known her and to have had the benefit of her knowledge and her dedication to teaching the valuable components and principles of painting.

The Nature of Painting and How it Relates to Painting Flowers

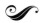

LOOK FOR THE LIGHT

If you can see you can paint. The difference between those who paint and those who don't is not talent, it's desire. So if you want to paint you must look at this world in such a way that you will make paint translate what you see. To do this, you must pay attention to an important fact: we really don't see *things,* we see the influence of *light* on things. Light makes colors and tones appear. Paint is a source of tone and color and can record what light does. The difference between paint and light is that paint is applied to a flat surface while light strikes objects in a three-dimensional world. In order to make your paint record this added dimension to the canvas you must realize that we live in a world with one source of light and it travels in a straight line. It can't illuminate the entire dimension of a subject. Those parts of the subject that are facing the light are illuminated and those not facing the light will be in shadow. So, the nature of lighting, as we know it, produces tone and color in light, and tone and color in shade. Recording the shapes of these contrasting tones not only makes images appear on the flat surface but also makes the images appear to be three-dimensional. There, in brief, is the simple foundation of the complexity of the painting process.

THE TIME FACTOR

Painting any subject matter takes time. When painting flowers, the limitation of time must be a serious consideration. You simply can't rely on the excuse: "The picture would have been better if the flowers hadn't died." If you want to paint flowers successfully, you must deal with the pressure of time. The best way to do so is to have your painting materials well organized and a plan for a practical, quick, direct procedure. Conserve time by realizing that the background, table and vase should only be painted — and thought of — as supporting cast members to the stars of your picture: the flowers.

A PAINTER'S OUTLOOK ON FLOWERS

Since painters are inspired by what surrounds them, it's safe to say that flower painters love flowers. It's a rare person who doesn't. Although there are some flowers that I like less than others, I don't dislike painting any of them when their look happens to provoke me. I feel that painting flowers isn't so much a record of them but a painting that has been inspired by them. Of course, you don't have to be a botanist to paint flowers but it helps to know something about them, principally how to keep

flowers fresh and also some tricks about arranging them. A day at the library with books on these aspects of dealing with flowers would be well spent; it could fortify you with some insights that can make your flower painting sessions easier, your results more satisfying.

EXPRESS YOURSELF

Before I get to the actual painting principles and procedures, I'd like to say something about painting as a means of self expression. The paintings of flowers in this book are my interpretations, and show my style of painting. Everyone has his own style; it's not something that's learned, it's developed. The information you gain from this book will, and should, facilitate your own personal pictorial statements. However, the most unfair thing you can do to your own self expression is to try to paint like someone else. If you try to emulate rather than understand, you will inhibit your painting style, much to the detriment of your development and the originality of your paintings.

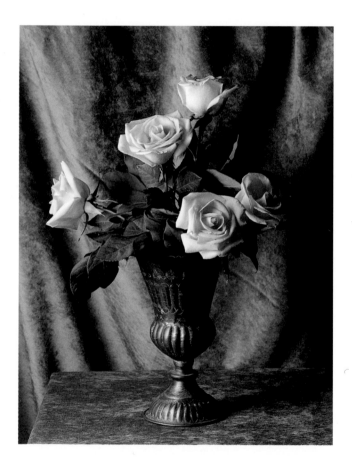

Suitable lighting for painting. *The light from the left illuminates the left side of the flowers and bouquet; the shadows on the right show off the subject's form. The cast shadows make the subject look like it takes up some space. These three tone values — body tone, body shadow and cast shadow — are the painter's actual elements of design.*

Unsuitable lighting for painting. *This lighting obscures the appearance of the flowers and bouquet and makes them look flat and pasted against the background. The lack of contrast can only produce a lack of design. Make sure you place your subject in the right light.*

Chapter 2
The Seven Components of Pictorial Expression

THE MEDIUM DOESN'T MATTER

Whether you paint with oil colors, watercolors, acrylics or pastels, your picture will be made up of *seven components* (or elements). Whether your painting is of flowers, people, places or things, it will have these same seven components. Whether the picture is the product of a child's innocent efforts with a crayon, a modernist's semi-abstraction with more sophisticated materials, or a realistic rendition, they all contain the seven components, which are ever-present. In many cases, painters are using these components for their pictures but are totally unaware that they are doing so. Let's see what these seven components are:

1. **Composition**
2. **Drawing**
3. **Tone Value**
4. **Rhythm of Application**
5. **Found-and-Lost Line**
6. **Color**
7. **Motivation**

Not one of these components is more important than the others. In a successful painting, they are consistently and completely interlocked. The components all work together to become a unified, successful presentation of the painter's inspiration. Once you become aware of these components, and how influential each one is to

the final effect, you will be on your way toward becoming more aware, which leads to better paintings. A more sensitive understanding of these elements will make your pictures improve — a development that is never-ending. Now, let's examine each of these seven components (page 16):

An Analysis of the Use of the Seven Components

*I've used my painting of sunflowers to illustrate the application of the painting components. The two large flowers constitute the focal point (without which a **composition** cannot function), balanced by flowers that extend beyond the picture frame on all four sides (indicated by arrows). The form of the flower, a result of its **drawing**, is defined by its basic anatomical structure — a cylinder. The lighting from the left shows off the flowers' dimension. The overall wild **rhythm of application** was suggested by the earthy, random quality of the sunflowers. The sharp and soft edges of the flowers and greenery are the result of an attention to **found-and-lost line**. Furthermore, we can't deny that there is contrast that is caused by the range in **tone values** and, of course, the **color** is there for all to see. Start to see your feelings about flowers in terms of the working components. They make it possible for you to express yourself.*

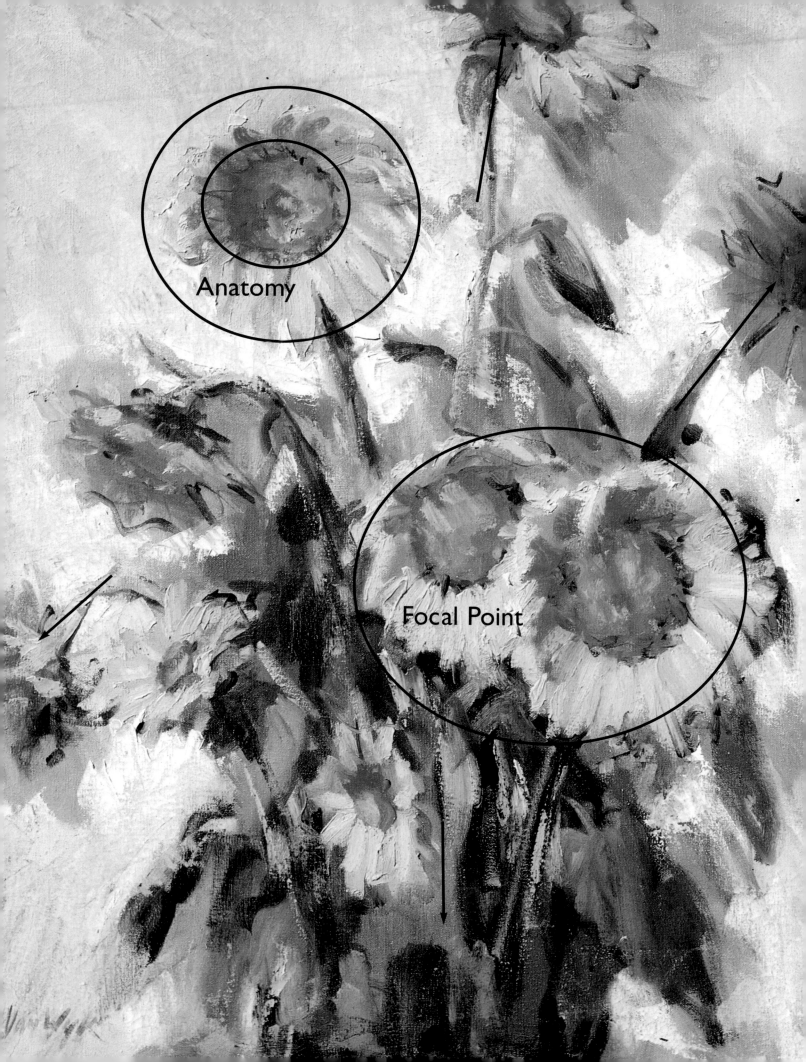

Anatomy

Focal Point

1. Composition

We use this word to describe the arrangement of the subject on the canvas. It is the design that the subject imposes on the canvas. It is the master plan that all the other components will further describe. A composition must always have a well-placed focal point — only one — and have *unity, variety* and *balance*.

2. Drawing

Drawing is the result of perspective, proportion and anatomy. *Perspective* — Space relationship. *Proportion* — Size relationship. *Anatomy* — The subject's structure or form. With every brushstroke, a painter deals with these three factors. Drawing and painting, however, are not the same; you draw a drawing but paint a painting. A painting, after all, is not a filled-in drawing.

An understanding of perspective, proportion and anatomy will guide your brush to make a subject look plausible. Always realize the way the subject looks in relation to your eye level (perspective); always look at its size in relation to the space it occupies (proportion); and think of the subject's construction instead of just looking at its outer appearance (anatomy).

3. Tone Value

Tone value is the component that causes contrast and dimension. Tone values in paint range from white (the lightest tone) to black (the darkest tone); from very light colors to extremely dark colors. One source of light causes five tone values to appear. These tone values are:

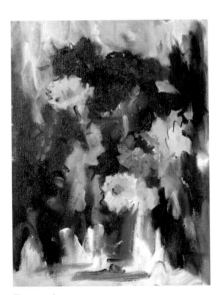

Figure 1.

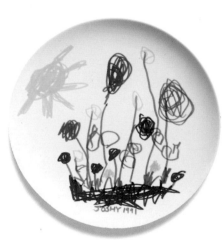

Figure 2.

Figure 3.

 The Seven Components

*Shown here are three very different pictures: a semi-abstract painting (**Figure 1**), a child's drawing of flowers (**Figure 2**), and a traditional painting (**Figure 3**), done by the author in pastels. While their interpretations can hardly be compared, their very makeup is the same: each one is a composition, each one has forms that are visible because of line or contrast, and each is done with a medium that dictates its character and gives it definition. These prove that all pictures are made of seven components. Can you say that the drawing by my student's son, Josh Mears — when he was three years old — doesn't have composition, drawing, tone, rhythm of application and found-and-lost line? His concept of flowers motivated him to do them in this way.*

1. **Body Tone or Mass Tone:** *The illuminated part of the subject.*
2. **Body Shadow or Mass Shadow:** *The part of the subject that's turned away from the light.*
3. **A Cast Shadow:** *An area shadowed by an object that stands in the way of the light.*
4. **Highlight:** *A spot that's in such a direct line with the light that the subject's color is obscured in the glaring illumination.*
5. **Reflection:** *A lighter tone in the shadow that's caused by the subject's surrounding area.*

It's important to paint the effect of one source of light. It not only makes a three-dimensional effect appear but it is the very nature of lighting in this world: one sun. When pictures respect this natural truth, they look valid and are acceptable to everyone. Any other kind of lighting has to be pictorially explicit.

The character of the paint is evident in this detail of one of my paintings. You can see the build-up of paint in the roses and although the paint thickness is reduced in the greenery, the nature of the strokes is compatible with that of the flowers. An important point to remember about rhythm of application is that it should be consistent throughout the painting, in various degrees, of course.

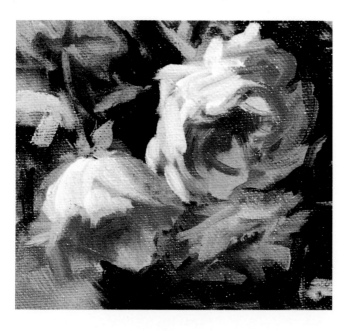

4. Rhythm of Application

The component that I call rhythm of application describes the look of the paint that is usually suggested by the appearance of the subject. It's caused by the manner of application, the type of brushes used and the amount of paint that's applied. Rhythm of application strongly influences the mood of the painting. It can be described as thick or thin, strong or weak, rough or smooth.

5. Found-and-Lost Line

The component that describes how contrasting tones meet each other to form a so-called line is best called found-and-lost line. Even though, in painting, there's no such thing as a line: an object's periphery, or outer edge, is delineated when one tone abuts another one. A found line (sharply defined) and a lost line (less sharply defined) are used in conjunction with each other to suggest a more three-dimensional appearance of the subject. Maybe "found-and-lost edges" would be a more suitable way to characterize this factor in painting. Whether it's called a "line" or an "edge," however, it is the component that makes the paintings of the thirteenth- and seventeenth-centuries look so different from each other. The paintings of the earlier era gave the appearance of figures being cut out and pasted against the background. The resulting hard edge made it difficult — if not impossible — to inject dimension into a work. I always like to say that in the seventeenth century they "found the lost line."

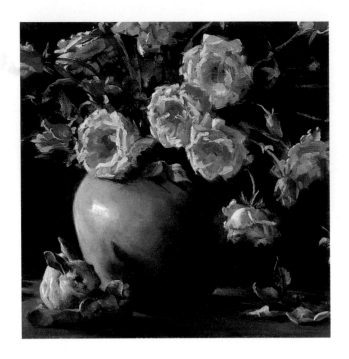

The five tone values — the component that causes contrast and dimension — are pointed out for you in the round, ceramic vase that holds the flowers. You will find these same tone values on the porcelain bunny and also in the flowers that are shown. Knowing what these tone values are will help you immeasurably to make your paintings look valid.

In this detail from one of my pictures you can see how the hard edge was implemented to make portions of the blossoms come forward, and soft edges used to make other parts go back. The same treatment has been applied to the flowers' stems to bring off this illusion of dimension in the picture plane. Keep in mind that you are always working on a two-dimensional surface; use every device that's available for you to add reality to this flat surface.

6. Color

Color is the component in painting that's considered to be the most important factor to add luminosity to the dimension that is caused by the tone values. There are six colors: yellow, orange and red (the warm colors), violet, blue and green (the cool colors). These colors have three properties — *hue, tone, intensity.*

1. **Hue:** *The identification of the color. For example, red, which can be either reddish violet or reddish orange.*
2. **Tone:** *How light or dark the color is.*
3. **Intensity:** *How bright or dull the color is.*

Dealers' shelves, as you well know, are stocked with tubes of paint that carry many color names. While a number of the color names are obvious as to their place in the spectrum, others, such as Burnt Sienna and Burnt Umber, to choose but two, are not. Identifying them is simple when you remember that every color is one of the six in the spectrum. In the case of the two colors mentioned, Burnt Sienna is considered to be an orange, Burnt Umber is classified as a yellow. The use of color in painting is explained fully in Chapter 10.

7. Motivation

The component that has no physical structure but is the inspiration for the six preceding components is motivation. Without motivation, the other components would be like an orchestra without any music to play. In fact, all of these components that are so easy to define by themselves can't really be dealt with one by one when you paint. For example, composition is not only the overall design but it is a factor to consider when merely adding a single bud as an afterthought. Tone and color are most often applied together as one mixture which is then set down in a rhythm of application that makes a shape. This painted-in shape can be sharply defined or vaguely suggested: the found-and-lost line.

Knowing that a picture is a result of the six painting components never lets you be completely innocent of a stroke again. It's like having a six-shooter in your hand instead of a mere brush.

The Three Properties of Color

🌿 **Hue:** *How colors change because they tend toward other colors.*

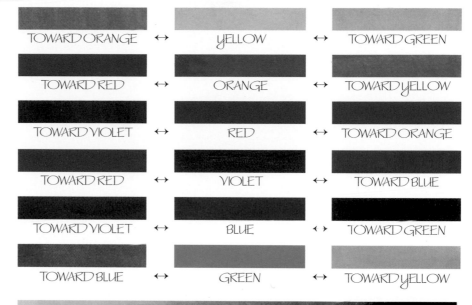

TOWARD ORANGE ↔	YELLOW ↔	TOWARD GREEN
TOWARD RED ↔	ORANGE ↔	TOWARD YELLOW
TOWARD VIOLET ↔	RED ↔	TOWARD ORANGE
TOWARD RED ↔	VIOLET ↔	TOWARD BLUE
TOWARD VIOLET ↔	BLUE ↔	TOWARD GREEN
TOWARD BLUE ↔	GREEN ↔	TOWARD YELLOW

🌿 **Tone:** *How colors change because of a range of values from light to dark. (Warm colors are most intense when they are light in value. Cool colors are most intense when they are dark in value.)*

LIGHTEST YELLOW ↔	DARKEST YELLOW
LIGHTEST ORANGE ↔	DARKEST ORANGE
LIGHTEST RED ↔	DARKEST RED
DARKEST VIOLET ↔	LIGHTEST VIOLET
DARKEST BLUE ↔	LIGHTEST BLUE
DARKEST GREEN ↔	LIGHTEST GREEN

🌿 **Intensity:** *How colors change because of their brightness and dullness.*

BRIGHT YELLOW	DULLER BUT NOT DARKER
BRIGHT ORANGE	DULLER BUT NOT DARKER
BRIGHT RED	DULLER BUT NOT DARKER
BRIGHT VIOLET	DULLER BUT NOT DARKER
BRIGHT BLUE	DULLER BUT NOT DARKER
BRIGHT GREEN	DULLER BUT NOT DARKER

Painting Materials

THE LIMITATIONS OF ANY PAINT

A painting medium — oil paint, in my case — is only stuff to record my pictorial point of view. Let's say I was marooned on a desert island with only a jar of molasses. I could use it as a painting material by mixing it with sea water to make various tones. Of course, my pictures would be monochromatic (all in tones of brown); that's the limitation of molasses. *But my point of view would remain the same.*

Inadequate supplies can impede your success, that's true, but on the other hand don't be deceived into thinking that fancy materials are primarily responsible for the quality of an artist's picture. The quality of your picture really rests with your appreciation and understanding of the painting components. With this in mind, just use your paints to put forth your own artistic way of seeing this world.

1. *A **surface to paint on.***
2. *A **paint** that offers a range of the six colors of the spectrum from bright to dull, from light to dark.*
3. ***Painting implements** to apply the paint.*
4. *A **paint thinner** that dilutes the thickness of the paint.*
5. *A **surface to hold and mix paints** before applying them.*
6. *A **place to work** with suitable lighting.*
7. *An **easel** to work on.*

A SURFACE TO PAINT ON

A painting surface for oil colors should be textured to ease the paint off your brush. Ideally, the weave of canvas is a texture of bumps and dents that helps make the paint stay on the surface. Primed with a substance that the manufacturer of the canvas prepares for you with materials that are sympathetic to oil paints, the paint will adhere to the surface. You can also prime (prepare) the canvas yourself because there are many different kinds of textures you can create that aren't commercially available.

Stretched Canvas

Due to the slight give under the pressure of your brush, a spanned surface is pleasant to work on. Stretched canvas is traditional; it was the only way that the artists of the past could have a large, flat surface to work on. Wood panels, which they used for smaller paintings, were too heavy in the large sizes. Canvas, they found, could be easily woven into any size. Linen and cotton were woven to the specified size, spanned in the artist's studio, then taken off the stretchers when the painting had been completed to be moved to the palace, church or any other building that it was designed to decorate.

Whether you buy canvas by the roll to stretch yourself or buy pre-stretched ones, the cost will be higher than other surfaces that are

available for oil painting. Cotton is less expensive than linen and it's durable enough for anyone's artistic efforts. Quite a number of my paintings, portraits as well as still lifes, have been done on stretched cotton canvas. If you insist on using linen, then I suggest that you buy single-primed rather than double-primed; it's more economical and it's been my experience that it's less likely to crack. Be prepared, however, to stretch linen yourself. Even though I've found some pre-stretched linen in Italy, in this country, only cotton canvas is available already stretched.

Canvas Board

A suitable surface for all kinds of oil painting. Don't get caught up with thinking of canvas board as an inferior, unprofessional surface in relation to stretched canvas. I've seen advertising for some very bad paintings (those imports from the far east) as being painted on "genuine artists' canvas." How silly! Wouldn't you be delighted to own a Rembrandt painting that had been painted on a canvas board? I would. In fact, I have a portrait that was painted on a canvas board by my late teacher, Maximilian A. Rasko. He did it in 1939; it's still in excellent condition. A rigid support — canvas board — will last a long time since the dangers of punctures and tears are minimal. My only objection to a canvas board is that it's not sympathetic to the pressure of my brushstrokes. Moreover, the texture is a general one, lacking the interesting textures that are produced by the loom. You can alter this, of course, by coating the surface with gesso, enabling you to create either a rougher or smoother texture. Incidentally, only use prepared artists' gesso for priming any surface for oil painting.

Masonite

Masonite is the trade name for an artificial wood material that's used by home builders. It's extremely strong and has been adopted by many artists as a durable painting surface. Use only untempered (oil free) and prime it with gesso. A number of artists will use the reverse — or rough — side to paint on. I've tried it and have found that the pattern of the texture is too uniform. I'd rather create my own textures by applying a coat, or more, of gesso to the smooth side and then using various devices to make surfaces that are unavailable in art supply stores. For instance, paint rollers can give you interesting effects; a hair comb stroked one way into the drying gesso and then stroked the other can create an exciting surface; and even pressing a piece of coarse burlap onto the drying gesso can prepare your surface with a fabric-like texture. Use your ingenuity to invent other ways to texture a board that's been primed with gesso.

I never use Masonite for any size that's larger than 16" x 20". I find that when I paint on any rigid support that's larger than this size I miss the pleasing, satisfying give of stretched canvas. And, of course, in much larger sizes — 24" x 30" and up — you'll run into the problem of warping, unless you use Masonite that's one-quarter of an inch thick, which makes for an extremely heavy support — and painting — to carry.

I'm sure that you have heard about other surfaces that artists are using for oil painting. As for which to use, your common sense should be your guide. Just remember, the surface has to be one that oil paint will adhere to. It can't be oily and if it's extremely smooth, it must be coated with an absorbing prime coat such as gesso. I'd like to mention here that I will use the generic word "canvas" throughout this book whenever I have to refer to a painting surface.

PAINTING IMPLEMENTS

M. A. Rasko once said, "Helen, if you know what you're doing you can do it with a broomstick. But use a sable brush, it's easier." The lesson I learned from this was that it was important for me to choose a brush that would make my job as easy as possible. Since there is such a variety of applications in painting a picture — from the beginning strokes to the signature at the end — an assortment of brushes is needed.

White Bristle, Red Sable and Synthetic Brushes

Generally, there are two types of brushes that artists use: bristle (firm texture) and red sable (soft texture). Both range in sizes from large to small. White bristle comes from hogs and boars whose habitat is the cold regions of China; red sable comes from tails of the Kolinsky, a weasel that's commonly known as the Red Marten. The animal gets its name from the Kola Peninsula in Siberia where it's called the Siberian mink.

These natural hair brushes are the most expensive of all on the market. You'll find many synthetic brushes (man-made hair) that simulate these types; they're priced lower and are very durable. The edges and points of synthetic brushes don't wear out, as bristle and sable will. The problems these brushes seem to have are stretching and curling. While the more expensive synthetic brushes will not curl, eventually all of them will stretch out of shape. But the prices are such that you can replace brushes regularly. With the ever-rising and prohibitively priced natural hair brushes making huge dents in artists' pocketbooks, synthetics are worth serious consideration. Moreover, their quality has been greatly improved. All sizes and shapes are readily available.

White Bristles

Although a great number of artists use white bristles exclusively, I like them, especially in medium and large sizes, for the beginning stages of my picture. I find that the white bristle brush can withstand the friction that's caused by painting over the rough texture of a canvas and helps me record the basic patterns of the composition. As Rasko always said: "Start with a broom and finish with a needle." Bristle brushes are manufactured in four shapes and in all sizes:

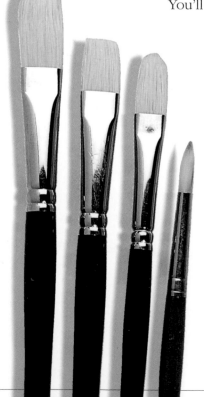

*I use white bristle brushes to begin my pictures. They are the workhorses of the painting process. Shown from left to right: **Flat** — for thicker applications of color; **Bright** — for laying in basic patterns of color; **Filbert** — for a good control of shapes; **Round** — for "petalizing" with thick paint.*

*My synthetic brushes do double duty because they have the stamina of white bristles and, at the same time, can do the delicate work of red sable. The selection that I personally chose and had manufactured for me is called **"Overture"** because they open the work, just as a musical overture does. However, you can use these brushes almost to the very end of your painting, in effect, well beyond the first and second movements. To finish, you would need smaller sizes than the ones in this selection.*

White Bristle Brushes

 Bright: *Flat ferrule, short chisel-like shape with a straight end.*
Flat: *Flat ferrule, long chisel-like shape with a straight end.*
Filbert: *Flat ferrule, rounded end.*
Round: *Round ferrule, pointed end.*

For general painting, I prefer the filbert shape over the others. It's a combination of a flat shape and a round one, making it extremely versatile, especially when painting flowers. These are the sizes I use:

Size 12 *(about 1" wide): for backgrounds and large areas.*
Size 4 *(about ⅜" wide) through* **Size 8** *(about ⅝" wide): for the general lay-in of colors.*
Size 1 *(about 3/16" wide) and* **Size 2** *(about ¼" wide): for flower stems and petals.*

For glazing and smoothing out paint, I like white bristle Brights in large sizes, anything larger than one inch. If you can't find these large sizes in an art supply store, you may have more luck in a paint or hardware store where they stock brushes for house painting and varnishing.

Red Sables

I use red sable brushes for painting on top of the already layed-in colors. This is to refine and develop the basic shapes and also for the final touches. My red sable brushes are Brights that range from size 20 (about 1" wide) to size 2 (very small, about ⅛" wide). In this same size range, red sable filberts are quite pleasing to work with. If you want to paint with any of these "beauties," be prepared: they are frightfully expensive.

Blenders

When I want to feather over wet paint to fuse the colors, I use an assortment of large, soft brushes as blenders. The best of the white bristle brushes for this purpose is a flat shape in a large size (size 20, about 2¼" wide). Another type of brush that's perfect for blending is one that's made in Japan; it's called a *Hake* (pronounced hockey). Your art supply dealer should be able to get it for you.

Brushes are expensive and perform best when their shapes are kept like new. Keeping your brushes clean is the obvious way to extend their lives. Another way to keep your brushes living longer is to use a brush that's best suited to the particular application that happens to be part of the picture's development. Having many brushes on hand will be more economical in the long run than trying to make just a few of them perform as "Jacks-of-all-trades."

I use red sable brushes to develop my pictures. I have sizes that vary from large (#18 to small #4). The small sizes are great for all the little twigs and small accents of darks and lights. Word of advice — don't pick around too much with little brushes. Big beautiful patterns should never be destroyed by detail.

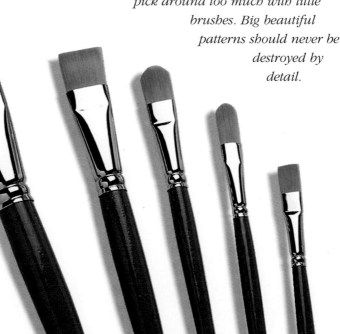

Red Sable Brushes

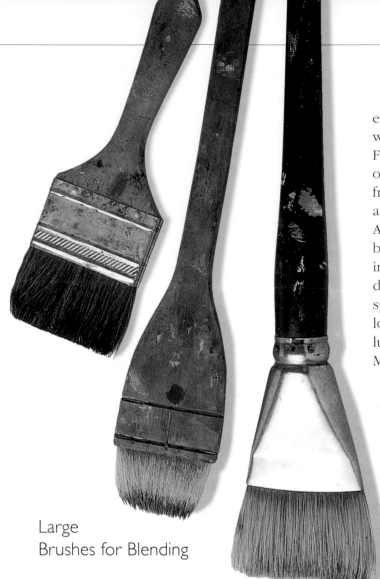

The most important part of your brush is its end. It's the only part that comes in contact with your canvas, making the shapes appear. Friction, as you know, will wear down any kind of material; what chance, then, does the tender, fragile tip of a brush have when it's rubbed against the texture of a rough-grained canvas? And once the natural ends of the hairs are blunted, the brush's effectiveness as a painting instrument has been diminished, if not destroyed. One way to avoid this: don't try to spread a little bit of paint too far. If a brush is loaded with enough paint, the paint acts as a lubricant that protects the delicate hairends. Moreover, a brush that's been loaded with paint will not need heavy pressure to apply the paint, thus reducing any of the ills that are caused by too much friction. Even when cleaning your brushes, reduce the amount of friction on them by using a liquid detergent instead of scrubbing the brushes vigorously over a bar of soap. Another danger of this practice, incidentally, is that it helps to push the paint up into the ferrule of the brush rather than flushing it out.

Large
Brushes for Blending

*I use very large brushes to blend in effects, pull the rhythm of application together and to undo brush work. The uses of large brushes make the finishing stages far more visible and charming. **Caution** — don't let these brushes get stiff with paint. They're useless if they're not as soft as a feather.*

I value my brushes so strongly that I never neglect to clean them properly and thoroughly. I do this by first cleaning out the paint with turpentine and then washing the brushes in warm (never hot) water and liquid detergent. I wash about four at a time, as shown, but none escapes my scrutiny. Each brush is examined and felt with my fingers to see if my cleaning process was thorough. I then rinse them in cool water, leaving a lot of water in them. I finally squeeze the water out from ferrule to tip to maintain each brush's beautiful shape.

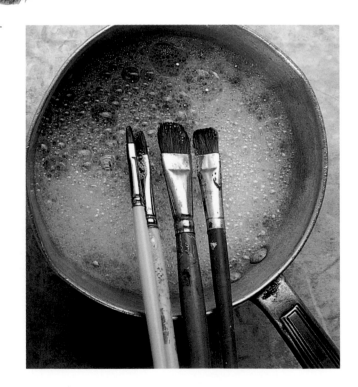

Painting Rags

Rags are usually thought of as a clean-up "tool," which, of course, is true, but their more essential use is to help the brush do its job well. I use a rag constantly to regulate the amount of paint on my brush between mixing the paint on my palette and applying the paint to the canvas. The only rag I use is Turkish toweling that I've cut into approximately six-inch squares. This size is less wasteful and is easy to hold in my non-painting hand. When one square gets too dirty to function well, I take another clean square, using four or five during a painting session. This way I use less toweling than if I worked with one big piece. Don't substitute Turkish rags with facial tissues, paper towels or even old bedsheets, and still think you'll get the same results. These materials can't absorb the wetness of the paint on the brush. And since they don't have the texture of Turkish cloth, they won't be able to pull the excess paint off as nicely and as easily. I can't stress too strongly how a Turkish rag works to make your brush perform better.

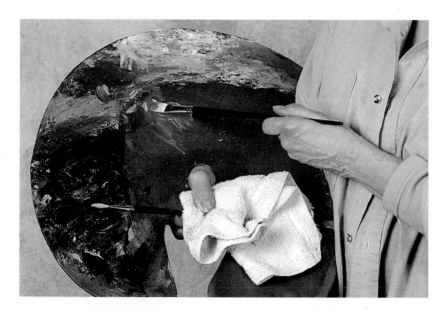

I think of my painting rag as my brush's silent partner. I hold the rag against the palette with my thumb, an ideal spot because it's so close to the mixing area, and my brush has to be wiped constantly. A brush that has just mixed color, you see, is not really loaded correctly to make beautiful, intricate shapes.

Wiping the brush clean of the excess paint from the mixing process gives you the chance to reload the brush properly. Sometimes, the painting process needs a brush that's only slightly saturated with paint. The amounts of paint on the brush can only be controlled by a handy rag. Basically, it works in this sequence: mix, wipe, reload.

MEDIUMS

There is more confusion and misconceptions about painting mediums than any other painting material. For some reason, non-professional painters think of mediums as the magic potions that are solely responsible for the beautiful effects in paint. I wish that this was true, but I must tell you that it's sheer nonsense.

Since paint from the tube is thick — often too thick for the necessary application — it needs a medium to thin it. Therefore, think of a medium only as a thinner; think of a medium as a means of altering the consistency of the paint to ease its application.

My basic medium is turpentine, and I use pure gum spirits of turpentine as well as the rectified turpentine that art supply stores sell. I use the relatively less expensive pure gum turpentine to ease the flow of my paint, to clean my brushes between mixtures and to clean my brushes after each day's painting session. I save my rectified turpentine for one purpose only: to mix with linseed oil and damar varnish for an all-around painting medium, principally one to glaze with. When I referred to pure gum turpentine as "relatively less expensive," it was in comparison with the rectified variety. The price of pure gum turpentine, you will find, is also in the stratospheric regions of art supply costs. With this in mind, I've begun to use the far cheaper paint thinner to clean brushes and also for general duty as a clean-up agent, thus saving the more expensive stuff for the actual painting. Paint thinners can be purchased at hardware and painters' supply stores and is also beginning to show up on the shelves of art suppliers.

The only other medium that I use is a mixture of turpentine, linseed oil and damar varnish in equal parts. It's a good all-round medium, especially good for glazing. Many art material manufacturers make and market a painting medium such as this one which you should buy if you don't want to bother mixing your own. Whether you make it yourself or buy it, this medium and turpentine are all the mediums any

A WAY TO RE-USE TURPENTINE

Don't use the small palette cups for turpentine and cleaning brushes. They were never designed for these purposes. Palette cups are for mediums to thin the paint as you mix it on the palette. A better way to keep your brushes clean during the painting process is to use a brush cleaner that you can easily make with a one-pound coffee can and a smaller can, such as one that tuna fish (or cat food) comes in. With an awl, punch holes in the tuna can and place it into the coffee can, punched end up. Then half fill the coffee can with turpentine. You'll find this an economical way to use turpentine because the paint pigment settles to the bottom, leaving the turpentine clean for future use. It's certainly much better than working with a little at a time, then throwing that amount away each time it gets dirty. Furthermore, using an ample amount of turpentine will allow you to slosh your brush clean without damaging its shape.

artist should need for general painting. Of course, there are mediums that I can call specialty items, those that aren't used regularly in a painting. They are used to change the natural drying times of oil paints. One type will speed up the drying time, another type is used to retard it. There are mediums that add shine to the paint film and others that make the surface more dull. You should experiment with these mediums but only with the understanding that artistic content comes from the artist who uses the medium, never from the medium itself.

Many people who are new to painting are confused about the word "medium." The one that describes the material that you mix with paints (turpentine, linseed oil, etc.) takes as its plural "mediums." The other, that describes the paint itself (oils, watercolors, pastels, acrylics, etc.), is pluralized as "media." A final word about mediums: someone once asked me, after I had dipped into my turpentine, dried my brush a little, picked up a color and applied it to the canvas rather successfully, "Helen, what did you mix with your paint?" I answered, "Brains." As much as I'd like to take credit for that brilliant retort, I must give the credit where it's due, to English artist John Opie (1761-1807). And this loan of a quote leads me to another, this one by Woodrow Wilson, who said, "I use not only all the brains I have but all I can borrow."

Mahlstick

A mahlstick is a rod that's used to steady your painting hand. It's held in your non-painting hand, of course, and propped against the edge of the canvas. A wooden dowel (36 inches long) is ideal. Art material stores carry an aluminum mahlstick that will fit your sketch box because it comes apart into three sections.

A STUDIO

A place to study and work can be simple or elaborate, but it's extremely necessary that your studio should always be there. A studio that has to be set up and taken down all the time is not as conducive to painting as a permanent installation. Many students have to go to art class constantly simply because they lack a place to paint at home. But much of the study of painting is a matter of self study and experimentation, thus making a studio where you can be alone a must for development of technique and style. Your studio can be just a corner of a room with painting equipment neatly organized. It's possible that this arrangement may conflict with the decor and look of the room, but if painting is to be done and studied, a studio has to take priority.

A WAY TO STEADY YOUR HAND

A **mahlstick** is a painter's stick, from the Dutch *maalstok*. It's used to steady the painting hand by resting it on the stick that's propped against the edge of the canvas. You'll find that this device is much better than resting your hand on the painting or having a shaky hand because you're afraid of steadying it on the wet paint.

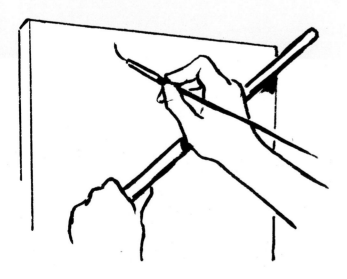

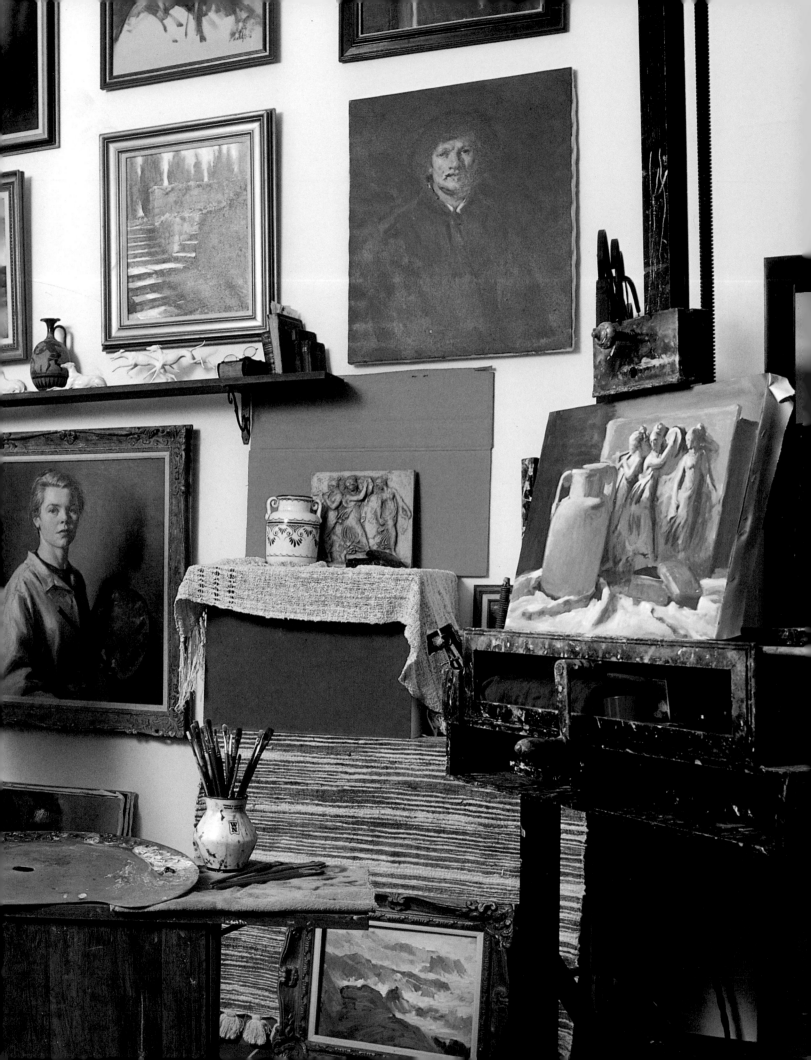

EASEL

The piece of equipment that converts any space into a studio is an easel. It got its name from *ezel,* the Dutch word for donkey. Makes a lot of sense since the easel is the workhorse of the artist's studio, the carrier of his creation.

No matter what kind of easel you choose to use, it's essential that you use it properly. Most important, never situate your easel in direct illumination, not only because this will cause your canvas to glare but your colors will look deceivingly light. If a color looks dramatic in strong illumination will it look the same when it's removed from this lighting condition? No. It's far better to paint in low light. Colors will maintain their character and even look brighter when they're viewed under general lighting conditions.

Another problem that students have with their easels is not knowing how high to adjust the canvas on the easel. Here's a good way to know the right height: make sure that your painting hand will be no higher than your shoulder. You'll find that this position is the most comfortable one for you. At the same time, the glare on your canvas will be reduced because you will be looking down slightly at your work.

When selecting an easel for your studio, avoid the shaky tripod kind; choose, instead, one that will hold your canvas upright. In fact, it's better to tip the top of the canvas towards you, another way to eliminate glare on your canvas.

Tilted Easel

The best way to avoid a glare on your canvas is to keep it in shadow. It also helps to tip the top of your easel forward.

A substitute for north light is a spotlight that's placed close to the subject, illuminating it in such a way that you'll see strong contrast.

Spotlight

 On my easel, in this photograph, is the start of the painting that I've been working on from the subject matter on the model stand against the wall. You can also see here the self portrait I painted in 1960 and some other paintings that are in my private collection. Please notice that my north light comes from the left, my preferred lighting arrangement. This studio is also equipped with fluorescent lighting in conjunction with incandescent to produce a blend that approximates, as closely as possible, natural lighting. I will use this lighting on overcast days and on those rare occasions when I'd work at night.

Palette Knife

A handy implement that's used to clean the mixing area of the palette while painting. You can also utilize your palette knife to scrape mistakes off the canvas; it's far better to do this than adding a correction to the already painted mistake.

Even though there is a wide variety of painting knives on the market, many artists will use their palette knives for this purpose. Unless you plan to specialize in painting with knives, as a number of artists do, a palette knife will perform this function quite adequately. You should try painting with a knife if only to force yourself to apply a lot of paint, which is much preferred to starving your canvas of color. After a while, this more promiscuous use of paint might brush off on your brush.

Don't pre-mix colors on your palette with a palette knife. I've seen so many students grind their colors to death on their palettes. This habit tends to make you overmix the paint, deaden the color and, more important, makes you mix too much of it. A painted area has more vitality when it's painted with slight variations of a color than one that's painted with an even coat of one color.

Lighting

Light from a north window is perfect for a studio because it doesn't change, it's harsh, and it's not very flattering. That hardly sounds like good reasons to paint with north light. But just consider this logic: if a painting can be made to look rather decent in this kind of severe lighting condition, how much better will it look when it's viewed in softer, kinder lighting?

If the north light in your home is not handy to use for a studio, or if this lighting is non-existent, you can turn any room into a studio by using artificial lighting. Shine a spotlight on your subject in such a way that the five tone values appear *(as explained in Chapter 2)*. Have the room generally illuminated so you will have enough light to see your canvas. The light that shines on your subject should be stronger than the one on your work.

Table for Your Subject

The item that most beginners forget about when they outfit their studios is a table on which to set up their still life subject matter. Get a table with wheels so you can move it around into lighting that's advantageous without disturbing the arrangement of your setup. A sculptor's stand, if you can find one, is splendid; it turns and its height can be adjusted, giving you a chance to look at your subject at different levels of perspective.

Shadow Box

A handy contraption, it serves to hold up different toned backgrounds that are so important to showing off the subject. It also blocks out any light that may interfere with the direct lighting that shines on the subject. A large corrugated box with two sides cut away makes an adequate shadow box that's light in weight. Anchor it down with a piece of Masonite that will also serve to reinforce its lightweight structure.

Backdrops

Drapes of light, medium and dark tones are all you'll need to choose from for possible backgrounds that will show off the subject artistically. Of course, you can have drapes of many colors and textures to add excitement and variety.

Table for Your Equipment

I use an inexpensive typewriter table. It has wheels, is light in weight and can be moved easily. What's more, it's just the right size to hold my materials. Don't clutter up your painting table! The only items you should have on hand as you paint are: your palette, turpentine, medium, rags and brushes. You should keep your tubes of paint in a paint box or in a drawer that's not at your easel. If you run out of a color on your palette, getting away from your easel to replenish it will also give you the chance to get away from your work for a minute, time away that's so important to evaluating your picture's development.

I can't stress strongly enough the value of good working habits. I realize that taking the time to organize and clean up is mundane compared to the passionate involvement of painting, but the painting process has to reside in an atmosphere of order.

My studio is part of our living environment. My easel and painting table are always there; all my other equipment is stored in a utility room nearby. Visitors often ask, "Where do you paint?" When I say, "right here," they remark, "but it's so neat." Why do artists have the notorious reputation of being sloppy? And why do so many people believe that the more sloppy an artist is the better and more authentic he is? But this is a fallacy. I have been in the studios of a lot of professional painters and not one of them was a mess. Surely, these studios were not as immaculate as an operating room, but they were interesting and well organized, neat and as clean as the craft allows or requires.

Make sure your painting table is uncluttered. The rule in my teaching studio is that students are only permitted to have at their easels the brushes they'll need, a palette, turpentine container (never glass) and the all-important rag. All other painting material is extraneous and must be out of the way. As for personal equipment — handbags, lunch, shopping bags, etc. — none can be anywhere near the painting area.

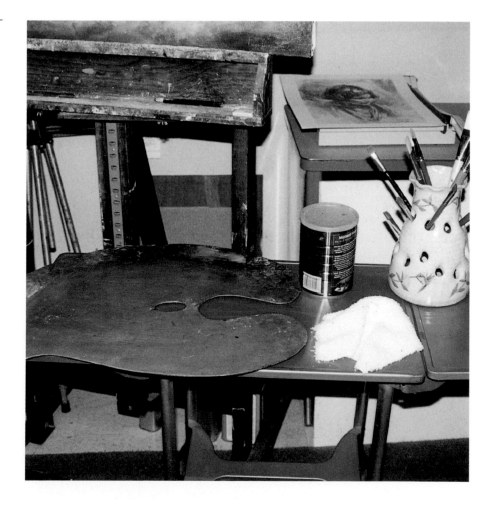

Chapter 4
A Palette, Paints and a Palette of Colors

PALETTE

A palette should be made of a non-absorbent material; varnished wood is ideal. It should be large enough to hold and mix paint, nothing smaller than 12" x 16". I'm accustomed to holding my palette; many other artists don't, preferring to have it nearby on a table. The choice is for you to make, although having one that you can hold at times, especially when closer color approximation must be mixed, is really the best. And, besides, it's arty looking too.

A palette should be neutral in tone. Never white! Never black! These two extreme tones are difficult ones to mix colors on. Clean your mixing area religiously after each painting session. The mounds of paint can be left on the palette from day to day. To store your palette for longer periods, put it in the refrigerator where the paints will stay wet for weeks.

A palette is the place where you mix your colors, determine the tone, the thinness or thickness of the paint, and judge the color in relation to the subject. It's your proving ground, a thinking place, and your most personal piece of painting equipment.

I don't have to tell you how popular peel-off paper palettes have become. I abhor them! While it's true that you don't have to clean peel-off palettes, this is a silly reason to buy one when you can see and appreciate how vital a palette's function is. And despite what you hear about the economy of paper palettes, they're really not economical at all; you have to replace the palettes constantly and with each discarded sheet, lots of expensive paint goes with it. I still have the wooden palette that was made for me forty-five years ago. Just the thought of

KEY TO THE COLORS OF THE PALETTE

Lightening Agent
1. Zinc White

Light, Bright Warm Colors
2. Thalo Yellow Green
3. Cadmium Yellow Light
4. Cadmium Yellow Medium
5. Cadmium Orange
6. Cadmium Red Light
7. Grumbacher Red

Darker, Duller Warm Colors
8. Yellow Ochre
9. Raw Sienna
10. Venetian Red

Still Darker, Duller Warm Colors
11. Burnt Umber
12. Burnt Sienna

Cool Colors, Dark and Intense
13. Sap Green
14. Thalo Green
15. Thalo Blue
16. Alizarin Crimson

Darkening Agent for Dark Colors
17. Ivory Black

how many peel-off palettes I would have had to buy during that period makes me shudder.

Since the colors on your palette are the paint substitute for the colors in light, there should be a sensible arrangement of these colors. I arrange my palette this way: White, as a lightening agent, at one end; black, as a darkening agent, at the other end. Then, I group the warm colors (yellow, orange and red) and the cool colors (violet, blue and green) between them. The illustration below shows this arrangement.

Important: Squeeze your colors out along the upper edge of your palette, close together, leaving optimum mixing space. By arranging them this way, it's easy to see how the mixing area of your palette can be cleaned with a rag as the painting session progresses without disturbing the little reservoirs of paint along the top edge. I'd like to point out that the arrangement that's pictured below is for a right-handed person. Since righties think from left to right, white is placed at the beginning and black at the end with all the colors in between them. I'm a left-hander and I think from right to left; I arrange my palette in an order that's a reverse of the one shown. I'd like to direct all left-handed readers to do the same.

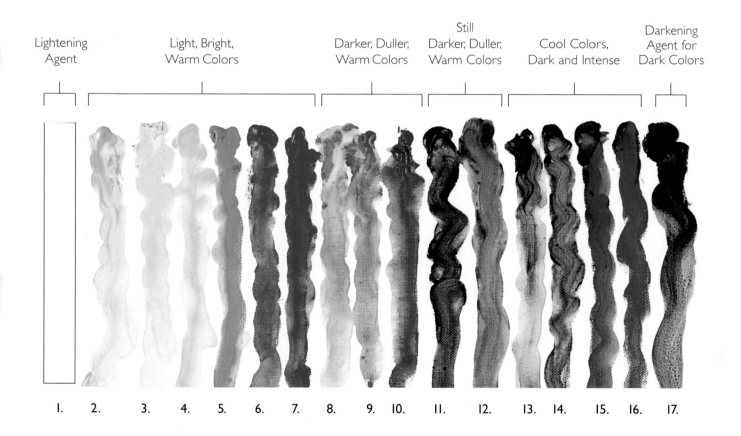

| Lightening Agent | Light, Bright, Warm Colors | Darker, Duller, Warm Colors | Still Darker, Duller, Warm Colors | Cool Colors, Dark and Intense | Darkening Agent for Dark Colors |

1. 2. 3. 4. 5. 6. 7. 8. 9. 10. 11. 12. 13. 14. 15. 16. 17.

An artist's palette can be compared to a pianist's keyboard.

Just as a piano's notes are always there, you should arrange your paints in the same order all the time. Never squeeze your colors out at random; have a system. Even if you don't need all the colors, squeeze out the ones you want to use in the same places. This order will make you feel secure, a posture that's so necessary to expressing yourself freely.

PAINTS

Oil paints are pigments that have been traditionally mixed with linseed oil. Today, oils such as poppy, safflower and walnut are being used for whites and other light colors, apparently because these oils have a tendency not to darken as much as linseed oil does.

Oil paint is a relatively easy medium to use; it dries slowly, which leaves you enough time to work at an effect. Another advantage of this slow-drying quality is that mistakes can be easily wiped off. Of course, you have to recognize when you've made the mistake; this is the most difficult part of the painting process.

The colors on my palette function very much like the instruments in a symphony orchestra. As you will shortly see, when I describe the colors on my palette, I choose the brilliants, the mediums and the deeps of each color to give me the fullest range I can get. An orchestra does the same thing in the string section — the violin, viola, cello, bass; in the woodwind section—the oboe, clarinet and bassoon; in the brass section — the trumpet, trombone, horns and tuba, and so on. Here, then is my arrangement — or palette of colors — for painting flowers:

The Lightener

Zinc White: A clean tinting white. It is slow drying which enables you to have one surface of color respond to a second application of color. This is so necessary to fusing or blending your colors.

The Bright Warm Colors

Cadmium Yellow Light, Cadmium Yellow Medium, Cadmium Orange, Cadmium Red Light, Grumbacher Red: Yellows, oranges and reds that are absolutely essential to record the bright yellow, orange and red of flowers. I must caution you to never use Cadmium Red Medium

or Cadmium Red Deep when painting flowers. These colors do not keep their brilliance when mixed with white. If you want only one bright yellow, make sure it's Cadmium Yellow Light. Cadmium Yellow Medium is not versatile enough in intensity to be a basic yellow.

The Duller Warm Colors

Yellow Ochre (yellow), **Raw Sienna** (orange), **Venetian Red** (red), **Burnt Umber** (yellow), **Burnt Sienna** (orange), **Indian Red** (red): These are duller, darker yellows, oranges and reds, used mostly in admixture with grays for backgrounds and foregrounds. They can be also mixed with the bright, warm colors to darken their values.

The Cool Colors — Violets

Thalo Red Rose, Alizarin Crimson, Manganese Violet: Indispensable for violet hues or cool grays when mixed with gray, and to be mixed with reds for red-violet hues. Never think of these colors as a source of pink. Pinks are made with white mixed with reds such as Cadmium Red Light, Grumbacher Red and Venetian Red.

The Cool Colors — Greens

Thalo Yellow Green, Sap Green, Thalo Green: These greens will give you the full range of tones and intensities when mixed with white, grays, yellows and oranges.

The Cool Colors — Blues

Thalo Blue: The only blue on my palette because it's so versatile. It's very brilliant but very dark. Light blues can be made by mixing with white. It never has to be darkened and it can be dulled by mixing it into grays. Few

flowers are truly blue; they're usually blue-violet so Thalo Blue can be mixed into the violet colors for this range of colors. Incidentally, the designation "Thalo" is Grumbacher's registered name for the pigment phthalocyanine. Other manufacturers make this same color under their own proprietary names.

The Darkener

Ivory Black: When mixed with amounts of white, it is an easy source of tones of gray: warm ones with white and a warm color, and cool ones with white and a cool color. It can even be used to darken cool colors and make greens when mixed with bright yellows. Ivory Black controls the tones and intensities of the cool colors and widens the variety of muted tones of greens.

How to Get the Right Mixture

When you want to mix a color, ask yourself these four questions (the answers to them are always the same):

Q. *What color do I see?*

A. *One of the following: Yellow, Orange, Red, Violet, Blue or Green.*

Q. *What tone is that color?*

A. *Light, Medium or Dark.*

Q. *What intensity is the toned color?*

A. *Bright or Dull.*

Q. *What Hue is the toned, "intensified" color?*

A. *The peculiar kind of basic color that it is, such as: a red can be an orange-red or a violet-red. Or a yellow can be a green-yellow or an orange-yellow.*

These answers will then direct you to the correct color mixture, as shown in the following example of mixing the color of a yellow rose.

I made the chart on the following page to familiarize you with my colors and their charac-

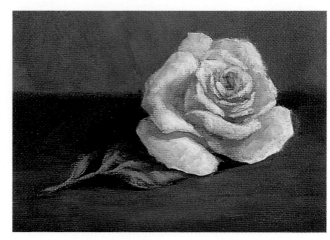

LDG

1. What color is it? Yellow.
2. What tone is it? Light.
3. What intensity is it? Not very bright.
4. What hue is it? Somewhat orange.

The **color** answer tells you that the color is either Cadmium Yellow Light, Yellow Ochre or Burnt Umber. The **tone** answer tells you that you need white in the mixture. The **intensity** answer tells you that the choice of yellow is Yellow Ochre. The **hue** answer tells you to add some Cadmium Orange to the mixture.

teristics. They're arranged the way I squeeze them out on my palette. Not counting white and black, eighteen paints are listed, but there are actually only six colors because they are all classified as any one of the following: yellow, orange, red (the warm colors), violet, blue, green (the cool colors). You'll find each color's identity in the column that's labeled "Hue." The chart will also let you know about the colors' tones (or values): how light or dark they are; their intensity: how bright or dull they are; their hue: how the colors deviate from their absolute place in the spectrum.

The Light, Bright Warm Colors

| TUBE COLOR | HUE | INTENSITY | TONE | HELPFUL HINTS |
|---|---|---|---|---|
| *Zinc White* | *None* | *None* | *Lightest Light* | *White is used to lighten colors and make them look illuminated. Don't think of white as a color, only as a lightening agent.* |
| *Thalo Yellow Green* | *Yellow Green* | *Bright* | *Light* | *Thalo Yellow Green can be mixed by putting a little Thalo Green into Cadmium Yellow Light and white, which makes it an opaque mixture. Tubed Thalo Yellow Green, on the other hand, is transparent and, therefore, can be used as a glaze. Thalo Yellow Green is ideal for flower painting since it's seen so much in foliage.* |
| *Cadmium Yellow Light* | *Spectrum Yellow* | *Bright* | *Light* | *Somewhat cool; makes light greens when it's mixed with greens and white. Obviously essential for painting yellow flowers.* |
| *Cadmium Yellow Medium* | *Yellow Orange* | *Bright* | *Light* | *Essential to making bright yellowish colors. Warmer than Cadmium Yellow Light.* |
| *Cadmium Orange* | *Orange* | *Bright* | *Light* | *Can be made by mixing Cadmium Yellow Light and Cadmium Red Light, but handier to have in the tube.* |
| *Cadmium Red Light* | *Red Orange* | *Bright* | *Light* | *The only Cadmium Red I'll use. Tints out slightly orange.* |
| *Grumbacher Red* | *Spectrum Red* | *Bright* | *Light* | *A red that tints out very bright and clean with white.* |

The Darker, Duller Warm Colors

| TUBE COLOR | HUE | INTENSITY | TONE | HELPFUL HINTS |
|---|---|---|---|---|
| **Yellow Ochre** | **Yellow** | **Medium** | **Medium** | *Indispensable yellow that's seen in nature and is needed in admixture with reds for lovely pinks.* |
| **Raw Sienna** | **Yellow Orange** | **Medium** | **Medium** | *Handy to have but you can do without it.* |
| **Venetian Red** | **Red** | **Medium** | **Medium** | *Just as important to have as a bright red but used less frequently. Mixed with white it makes pretty pinks.* |

Even Darker and Duller Warm Colors

| TUBE COLOR | HUE | INTENSITY | TONE | HELPFUL HINTS |
|---|---|---|---|---|
| **Burnt Umber** | **Yellow Orange** | **Dull** | **Dark** | *Good to add to a warm mixture when the intensity has to be reduced slightly. An indispensable dark, warm color.* |
| **Burnt Sienna** | **Orange** | **Semi-dull** | **Kind of Dark** | *A color found in nature; can't be mixed; very transparent.* |
| **Indian Red** | **Reddish Violet** | **Dull** | **Semi-dark** | *I seem to need it in my inter-mixes for background areas. A good accent color.* |

The Cool Colors

| --- | --- | --- | --- | --- |
| **Alizarin Crimson** | **Violet** | **Bright** | **Dark** | A good source of violet of many tones and intensities when mixed with black and white. |
| **Thalo Red Rose** | **Red Violet** | **Bright** | **Semi-dark** | Valuable in painting flowers that have a brilliant violet color. |
| **Manganese Violet** | **Blue Violet** | **Semi-dull** | **Dark** | Beautiful with Thalo Yellow Green and black and white for backgrounds. Use it to mute yellows into shadow. |
| **Thalo Blue** | **Blue** | **Bright** | **Dark** | As necessary as red because it's a primary color. The darkest and most brilliant of the blues. Lighter and less intense variations can be mixed with additions of white and grays. |
| **Thalo Green** | **Blue Green** | **Bright** | **Dark** | No combination of yellow and blue can make this beautiful, intense green. Mixed with Cadmium Orange, it makes a nice foliage color. |
| **Sap Green** | **Yellow** | **Medium** | **Medium** | A very natural looking green but quite transparent which means that it has to be applied rather thickly. |

The Darkener

| | | | | |
| --- | --- | --- | --- | --- |
| **Ivory Black** | **None** | **None** | **Darkest Dark** | Never use it alone! Use with degrees of white to make tones of gray. Add a warm color for warm gray, a cool color for cool gray. Use it to control the value of violet, blue and green. |

Let's Clear the Air About Color

Based on my experiences with students over a great number of years, I've run into many pre-conceived ideas that a large percentage of you have about some of the colors I've just described. Before we get into actual painting instruction, I'd like to clear the air right now about some of the more bizarre things I've heard concerning certain colors:

1. Don't use Thalo colors — they're dyes.
Not true! Dyes dissolve in their vehicles while pigments are held in suspension in their vehicle, in this case linseed oil. The Thalo colors are definitely pigments, just as earth colors and Cadmiums are. What confuses so many beginners is the fact that there are colors that are referred to as "staining" colors. Alizarin Crimson is one of them, also the Thalos. None of them, however, are dyes, as explained above.

2. Never use black — it's not a color.
White isn't a color either but no one would dream of doing an oil painting without it. The admonition to keep black off the painter's palette ignores the benefit of black as an agent to control the tones of grays and muted colors. Of course, you shouldn't use black alone or use it to make shadows; its rightful place on the palette was established centuries ago when artists used black without any prejudice.

3. Alizarin Crimson is a member of the red family. *This misconception has succeeded in getting scores of novice painters into a lot of trouble: they would mix white into Alizarin Crimson hoping to get a red but end up instead with a bruised purple. Alizarin Crimson is a violet and you can prove it by mixing it with white. You should only consider Alizarin Crimson a red when you mix it with another red or with an orange.*

SUMMING UP

The colors listed and described are my choice. The paintings pictured in this book were all painted with this palette of colors. I'm comfortable with them because they offer a complete range of colors from bright to dull, from light to dark. And they're all permanent. It's true that you can use fewer colors, and it might be fun to use more. But this palette of colors has passed the test of my experimentation with fewer and more colors. There are many other lovely, valuable colors available, such as Brown Madder, Prussian Blue, Payne's Gray, and other blues and violets. You may experiment with them, if you want to. You can see for yourself how they fit into the chart I've just presented to you.

A BASIC PALETTE
(from Mass Tone to its Lightest Tint)

 The Lightening Agent:
White is a lightening agent for all colors. Generally, any color that is illuminated has to have an addition of some white.

ZINC WHITE

 The Warm Colors — Yellow, Orange, & Red — in their lightest and most brilliant form:
To be used whenever you have analyzed a color to have a degree of brightness. Lighten them with white; darken them with darker versions of the warm colors; gray them into shadow with their complements: violet, blues and greens.

CADMIUM YELLOW LIGHT

THALO YELLOW GREEN

CADMIUM ORANGE

CADMIUM RED LIGHT

GRUMBACHER RED

 The Warm Colors — Yellow, Orange, & Red — in a darker, duller version: *Lighten them with white, but if you want them lighter and brighter, add white plus a brighter color.*

YELLOW OCHRE

RAW SIENNA

LIGHT RED

The Warm Colors — Yellow, Orange, & Red — in their darkest, dullest form: *These three tubed colors complete the range of tone and intensity of the warm colors. Use these whenever you have defined a color as dull. You can determine their tones by adding white.*

BURNT UMBER

BURNT SIENNA

INDIAN RED

 The Cool Colors of the spectrum — Violet, Blue & Green:
Unlike the warm colors, the intensity and tone of these cool colors are controlled by admixtures of black and white. White lightens and brightens them; tones of gray (black & white) lighten and dull them. They hardly ever have to be darkened since, as you can see, they are already extremely dark. They can be grayed into shadow by mixing darker tones of their complements: yellow, orange and red.

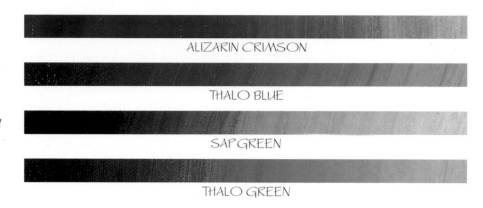

ALIZARIN CRIMSON

THALO BLUE

SAP GREEN

THALO GREEN

 The Darkening Agent:
Black is a darkening agent for dark colors, but is mostly used to make tones of gray when mixed with white.

IVORY BLACK

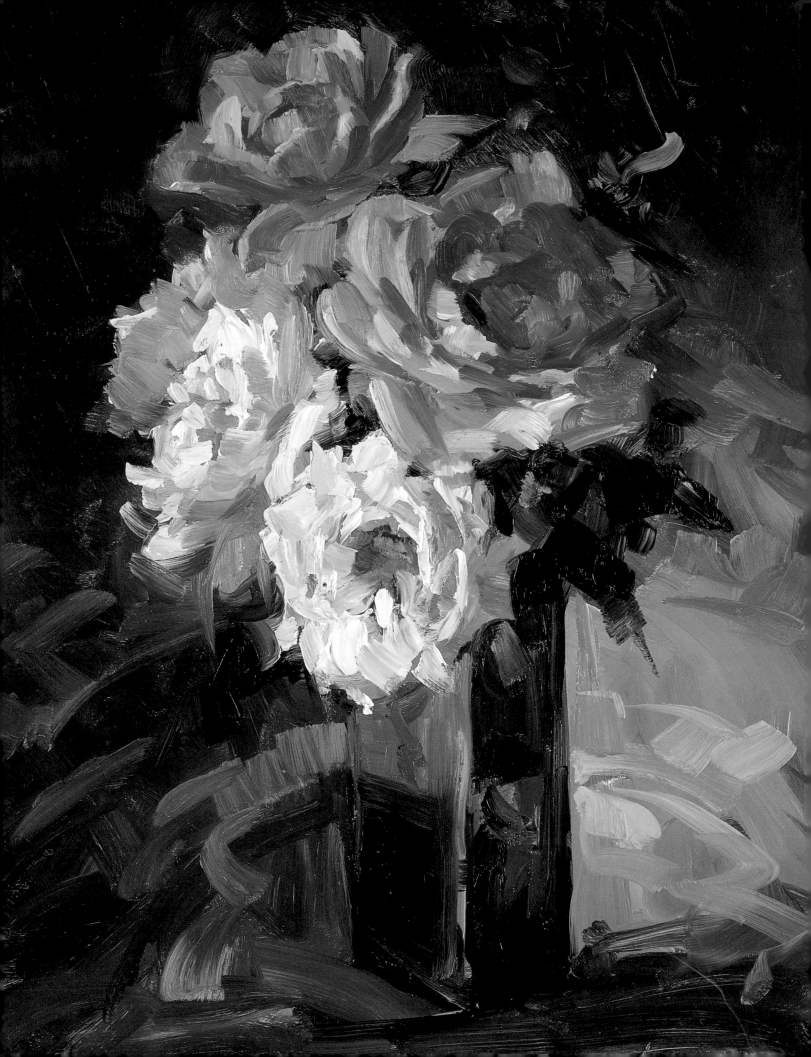

Chapter 5
Flower Arranging for Flower Painting

FLOWERS IN PAINT

The inspiration for a painting is usually sparked by a visual experience. Whether the flowers are in your garden or in a bouquet, you're always pleased to be in their presence. But these actual sensations can't be put down within the limits of the two-dimensional surface innocently. Your picture has to be painted in such a way that someone who looks at your painting will recognize the flowers and share your visual experience without actually having seen them. You can't, and shouldn't have to,

qualify and defend your picture under criticism by saying: "But that's the way they were." Here are some of my opinions that may help you in your consideration of flowers as possible subject matter for paintings:

1. Formal floral arrangements aren't suitable for flower paintings unless their formality is justified. You can do this by the setting you put them in, such as the arrangement in *Figure 1*. Often, a florist's arrangement can be adjusted to look a bit more casual by removing the extra greenery that florists usually add to fill out the bouquet. Also, just changing the container can rearrange the flowers. Or you can change the flowers themselves to be less formal and less symmetrical. I did all three with my painting of pink and red roses.

2. Actually, the background, foreground and vase can be more difficult to paint then the flowers themselves *(Figure 2)*. The flowers are there to see and refer to while the

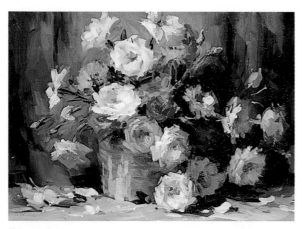

Figure 1.

 Figure 1. (above) *A florist's formal arrangement is not really suitable for a painting. For one, many florists' bouquets are too symmetrical. In order to paint this bouquet of roses, I had to make a few changes. I moved the uppermost flower slightly so it would not be directly above the middle of the vase. I also forced a focal point in the bouquet by overlapping the three flowers toward the lower right third of the arrangement.*

Figure 2.

Figure 2. I chose a light background to show off the silhouettes of the weeds and the vase. I also interrupted the straightness of the table line with the arrangement of the porcelain greyhound and with sprigs of baby's breath. I did this because straight lines in flower paintings are disasters; they conflict with the shapes of the flowers which are hardly straight and rigid, and any straight line will become more important than the flowers.

elements that surround them are the poetic tonal selection that puts them in an interesting and advantageous setting *(Figure 3).*

3. Arrange flowers in such a way that there will be a focal point in the arrangement, making sure that this focal point is a little off center. Another thing to be aware of is to make sure that the flowers aren't evenly spaced; have some overlap some others to give the feeling of depth.

4. Arrange the bouquet in the round, which means that you should have some flowers facing away from the viewer *(Figure 3).* This reinforces the three-dimensional effect.

5. When arranging flowers for a painting, keep in mind that the painting is more important than the flowers themselves; they are going to fade and die. Your painting of them, therefore, will be the only point of reference of these flowers; your painting will be the thing that people will look at and enjoy. Be careful, then, with the way you arrange your flowers. You have only yourself to blame if the picture doesn't work out well. Painting is time consuming and difficult, so be sure that the arrangement is worth your effort.

6. Remember, you are only making a paint interpretation not a reproduction of flowers. Many paint options are always there: (1) you can choose to make the paint thick even though the petals are thin; (2) your colors can be soft and pale even though the colors of the flowers are vivid and bright; (3) the size you make your composition can be one that fits the canvas nicely but does not necessarily have to be the size of the flowers themselves. The choice is yours.

7. On the other hand, there are factors that you have to respect. The most important one is the shape of the flowers. You'll never get a plausible presentation of the flowers if their shapes are not easily identified. You must arrange the blooms in such a way that will show up their lovely shapes and make them distinctive. Don't put one on top of the other, and when you do overlap them, try not to make them look like one big flower. Notice how discreetly the blooms are placed in relation to each other in *Figures 1, 2 and 3.*

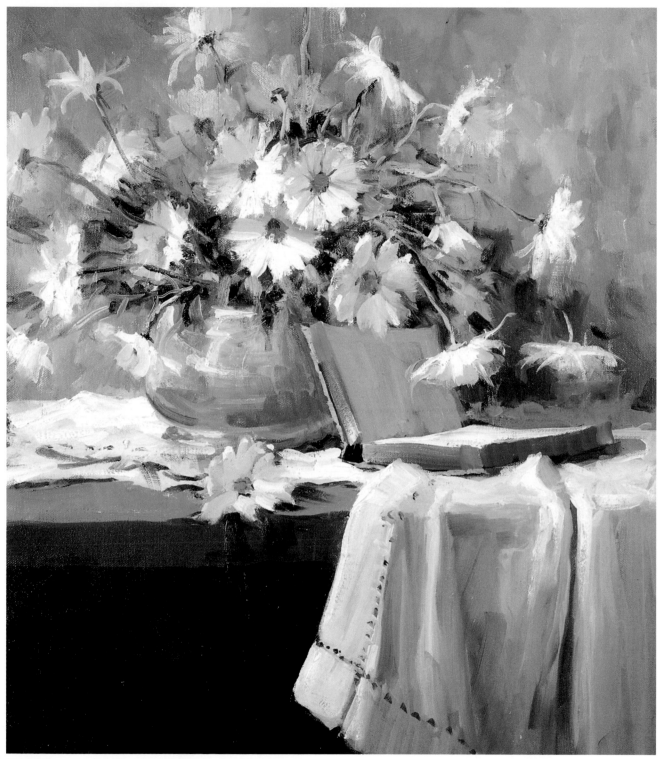

Figure 3.

Figure 3. These daisies on a table cloth certainly suggest a feeling of space due to the flowers being in all different positions. The placement of the bouquet in the upper left section of the canvas is balanced by the fullness of the drapery in the right lower section. The overall design of a picture is always the artistic intrigue, one of the reasons why I'm never bored by painting daisies.

8. Make your arrangement look natural. For example, all those flowers that you would normally pick should be put in vases or containers. Flowers that you would not usually pick should be placed in other containers or painted as if they are growing. This could apply to bulb type flowers, such as hyacinths, and to potted plants. A geranium should be painted in a clay pot since it's a flower that's seldom, if ever, picked **(Figures 4 and 5)**. Pansies look natural growing in flats or in a basket. As you can now see, some vases are suitable for certain flowers. However, if you want to make exceptions you have to be prepared to justify them in your picture. Roses, for instance, look right when placed in porcelain, silver or glass vases. But when placed in a basket, you will have to change the interpretation to accommodate the more casual mood that a basket provokes. Since Queen Anne's Lace is just a weed, I felt that a copper milk can would seem to be a suitable vase **(Figures 6 and 7)**.

9. An essential factor of flower arranging is the relative proportion of the vase to the flowers; these two sizes are never equal. Here's a basic rule: the flowers should be one-and-a-half times higher than the visible vase. In a wide arrangement, the ratio of width to height of the flowers should be three to two.

SUMMING UP

When arranging flowers for a flower picture, you must take a number of things into careful consideration:

 *1. The **silhouette** of the bouquet.*
 *2. The **flowers** themselves, make them overlap.*
 *3. The **background** that will help show off the flowers. Dark on light background, light on dark background.*
 *4. The proper **container** to be used for the flowers you plan to paint.*
 *5. The **foreground**.*
 *6. The **lighting**.*
 *7. The size of the **canvas**.*

Figure 4 is a photograph of the actual arrangement. Figure 5 is an interpretation of the subject. By not including a cast shadow, an outdoor setting for these outdoor flowers was suggested.

Figure 4.

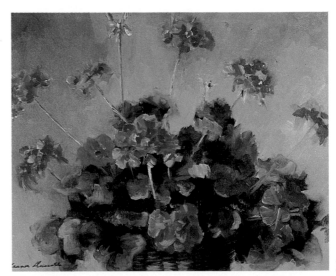

ED

Figure 5.

Once you start to paint, many problems will arise: placement, composition, interpretation, the factors of drawing, the tones, the colors and the time that seems to rush by. Some preliminary organization of your subject and painting equipment will contribute to your picture's success.

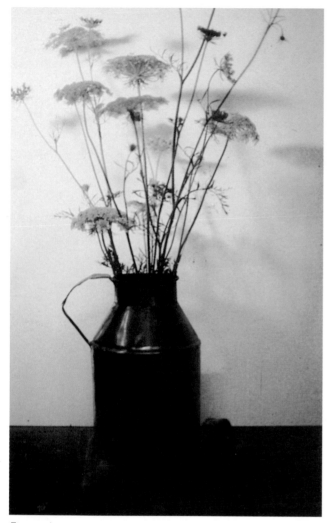

Figure 6.

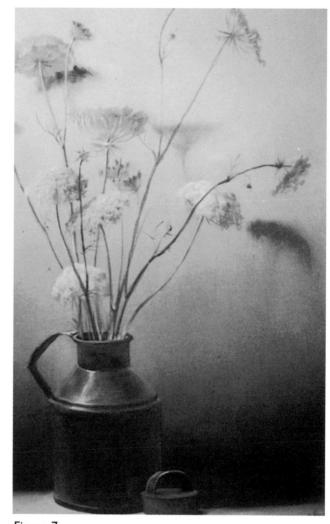

Figure 7.

Here we see a photo of the subject (Figure 6) and my painting of it (Figure 7). Notice the change that I made. Using this "poetic license," I disguised the table line by grading this light-toned background into darkness at the table line to avoid that straight line that I mentioned in the text. A variety of containers, you'll find, can inspire unusual flower paintings. Put a lot of thought into the setting of the flowers: vases, backgrounds, tables, all work together to make an artistic presentation.

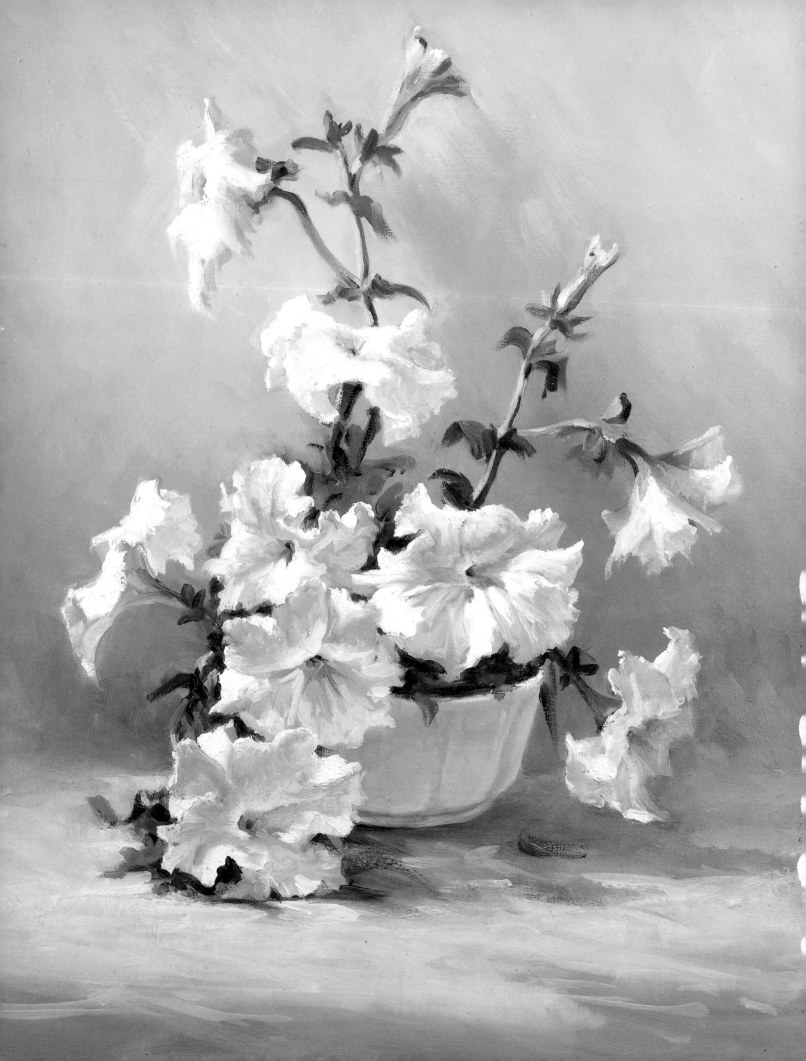

Chapter 6

How Motivation Influences Pictorial Expression

INTERPRETATION

All the painting components influence the interpretation of the subject. The one that affects the interpretation the most is motivation, a personal component that's difficult to describe with words. Even though a motivation has no physical substance, a picture is never painted without one. Motivation can be called your point of view, your outlook, how you are influenced by the subject matter. All of this must be translated into the possibilities of paint on canvas. Your motivation activates a "paint presentation." *Figures 1 and 2* are paintings of the same flowers — white petunias. And while the

canvas sizes and proportions are different to accommodate the change in composition, that is not the major difference in the paintings. The difference is the mood caused by the motivation, which made me handle the paint differently. *Figure 1* is a high key painting, on the cool side, and was painted a bit thinly with no remarkable paint identification. *Figure 2* is considerably warmer with the paint handled more thickly or with more impasto. I always think of the interpretation of the subject in the way that the paint looks. After all, I'm a painter not a florist.

MOOD AND APPEARANCE

A flower or a bouquet can be recorded with a camera very beautifully, using artistic lighting, composition and focus. The photographer knows he is making a photograph; he likes photography and its look. You as a painter should like the look of paint; you should be willing to accept its interpretive appearance. The result — rhythm of application, the look of the paint.

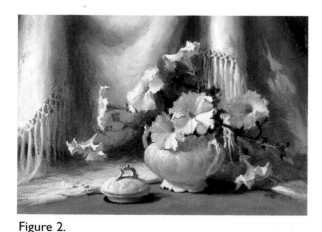

Figure 2.

 Figure 1. (opposite) *In this painting of white petunias in a white vase, the cluster of three petunias is my focal area. The greenery functions as subsidiary elements. Figure 2. (above) The petunias dominate the focal area in this picture as well as the sugar bowl that performs so well as a vase.*

Rhythm of application is noticeable when you compare the look and mood in two paintings that were pictured in Chapter 5: the geraniums and the Queen Anne's Lace. The paint in the geraniums is thick; the paint in Queen Anne's Lace is smooth. One has an earthy look, the other a refined appearance. The look of the paint isn't an accident; motivation controls its appearance. Motivation activates the desire for a pictorial effect.

A phrase that may better define motivation is "in the mood." I can look at the flowers on page 57 and only see them as a fact of actuality. Then, another time, I see them in terms of paint, color, arrangement, and all the things that can make them a painting. I've been motivated to put the picture-making components into action.

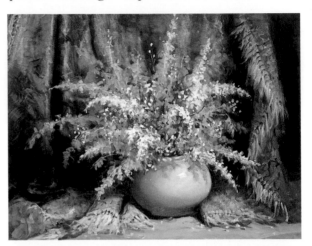

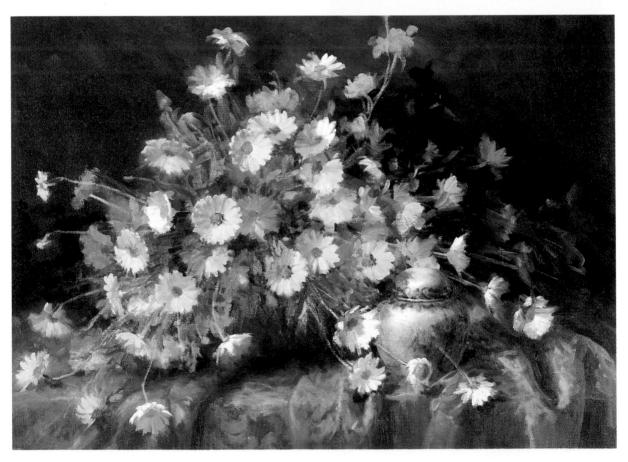

The overall appearance and mood of these two paintings are quite different. The lower one of the yellow marguerites addresses the viewer directly on account of its strong contrasts. The softer, muted tones of the upper picture — the weeds — seem to suggest a more introverted mood. Your interpretation of the contrasts is your option, dictated by how you are impressed.

Chapter 7
Composition

UNITY, VARIETY, BALANCE

Since you want your pictures to be your paint comment on nature, you'll have to look to nature for some of her rules. In nature, there are three elements: unity, variety and balance. Any painting that has these three elements will look more acceptable than a painting in which these factors of composition have been ignored. A person looking at a composition is unconsciously disturbed if it's off balance; is bored if it lacks variety; and is confused if it has no unity.

Composition is also largely a matter of taste. For this reason, it's hard to tell you what to do and what not to do. A mistake in composition is never planned, it's something that just happens because either you didn't notice it or you didn't think at that time that composition was a factor. There are some reliable basic rules of composition. Once you know them, you can break these rules if you have a good reason to do so. Sir Joshua Reynolds said: "No weight nor mass nor beauty of execution can outweigh one grain or fragment of thought." *Here, then, are some compositional "don'ts":*

1. Don't make equal divisions, not only in placing the entire bouquet but also in spacing the flowers within the bouquet *(Figure 1).* Placing the focal point in the middle makes equal divisions of space, which is monotonous.

2. Don't place the focal point too near the edges of the canvas unless you can balance

this placement. One way to test your composition for balance is to put the palm of your hand under the canvas (held flat, face up) at the place where the focal point is. If the canvas tips greatly enough to fall off your hand, then support it with a finger of your other hand at the point where you can balance the canvas. At this place, you should add something to your composition to strike a balance.

3. Don't use unrelated subject matter or unrelated brushwork in the same composition. What you'll get is variety but your painting will lack unity; your pictures should have both, variety while maintaining unity. You can compare this factor in composition to musical composition: unity is the theme, variety is the variation on that theme.

4. Don't do anything that drains the interest from the focal point. You'll end up with two focal points or with none at all. You'll find that this mistake usually happens when the background and foreground are painted without any regard to the subject.

5. Don't make objects in your composition just touch each other. I find this mistake constantly in students' paintings. It's a fault in composition that creates awkward shapes and obscures the beauty and form of the subject matter. When edges touch this way, I call this mistake "kissing." To avoid this, place and paint objects in such a way that they either overlap each other or stand

alone by themselves. So — please don't kiss on canvas *(Figure 2 – Correct)*.

6. Don't make your elements the same size, such as the size of the vase being the same size as the flowers. Again, you'll have monotony. Of course, with a bouquet that contains the same kind of flower, there will be a repetition of size of each flower but shapes or patterns of light and dark can disguise this repetition, as you can see in *Figure 3b.*

7. Don't make a round-shaped silhouette of a bouquet.

8. Don't paint your flowers all facing in the same direction.

Here are a few compositional "dos":
1. Make sure your picture has only one focal point.

2. An object can be placed in the middle of your canvas, but the focal point can't.

3. A focal point happens where there is interesting, strong contrast.

The all-important focal point can never be in the middle, can never be near the edge of the canvas, and can never make an equal division. The only area that's left for the focal point is any area on the canvas that's left over, as seen in the right-hand diagram in *Figure 4b.*

Figure 1. – Wrong

Figure 1. – Correct

Figure 2. – Wrong

Figure 2. – Correct

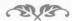

Figure 1. – Wrong. Shows in how many places equal divisions can occur: equal spaces between flowers, equal distance of the entire bouquet from edges of the canvas, the focal point dividing the canvas in half and the table line dividing the vase in half.
Figure. 1. – Correct. Shows how a varied distribution of space is more pleasing to look at.

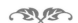

Figure 2. – Wrong. Shows how the beautiful appearance of flowers is jeopardized by having flowers just touching. They look like one big flower and they give the appearance that they're on the same plane instead of being one in back of the other. I call this "kissing on canvas."
Figure. 2. – Correct. Shows how overlapping the flowers suggests more dimension and presents a variety of shapes.

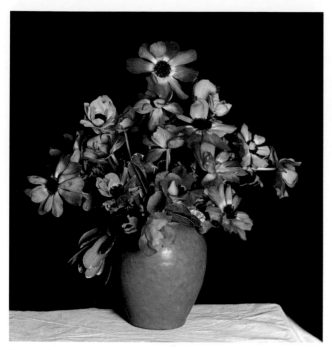

Figure 3a.

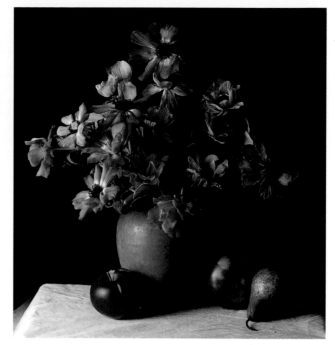

Figure 3b.

 Figure 3. The floral setup on the left has been photographed with light coming from the front. The one on the right has light coming from the left. Lighting from the left (or right) instead of from the front causes more interesting, varied patterns. Create a beautiful composition by looking for shapes of contrast rather than shapes of flowers.

Figure 4a.

Figure 4b.

Figure 4. A focal point is an area of the canvas. You should only have one focal point per picture. The diagram at the left (Figure 4a) shows a focal point that leaves too much space to be filled; it also illustrates the deadly equal divisions from subject to canvas and the right to the middle of canvas. The diagram at the right (Figure 4b) shows an ideal focal area on the lower left of the canvas. It can be in the same relative position, as shown by the circles printed in blue.

BACKGROUNDS & FOREGROUNDS

In composition the subject is referred to as the positive space and its surrounding area is the negative space. Both areas are well named for the sake of composition because one must support the other. In flower painting the negative space is the background and foreground; the bouquet and vase the positive space.

Atmosphere & Setting

Backgrounds dictate the atmosphere and setting of the picture. You have three options for a background: light, medium or dark in tone.

 Light Background: Makes the flower colors look dark. (Figure 5.)
Dark Background: Makes the flowers look light and makes it easier to illuminate the colors of the flowers even if they are dark. (Figure 6.)

Medium Background: Can only be used for light-colored flowers.

An ideal background that adds a lot of dimension is one that ranges from light to dark — dark on the side of the canvas where the light comes from, and light where the light is going. The light side of the flowers is then up against the dark part of the background and the shadow side of the flowers appears against the light part of the background *(Figure 7).*

The amount of background shown can be large, making the bouquet look as though it's far away. Limiting the amount of background, however, will put the bouquet up front. Always decide on the amount of space your bouquet will take up by marking its size in relation to the size of the canvas. If the bouquet would look better being off center, then it is best to

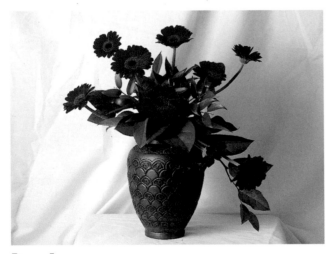

Figure 5.

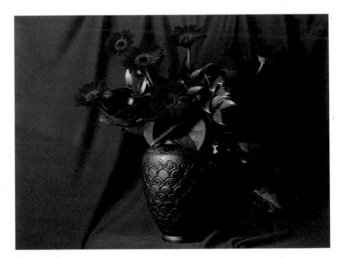

Figure 6.

 *Your choice of background is the best way to show off the colors of flowers. Student painters rarely realize the limitation of the pictorial in relation to the actual. This often leads to the frustrated remark "I can't get the color." You can't get the color, that's true; you can only present it. Let the choice of the tone of the background help you do this. The photo in **Figure 5** pictures dark red gerberas. These same dark red gerberas look light in **Figure 6**. It is the tone of the background that causes this drastic change in tones of the same colored flowers. What does this mean? For one, only a small amount of white can be used to paint the red flowers in **Figure 5**. On the other hand, the flowers in **Figure 6** can stand an addition of white to make them a tone that's lighter than the background. Conclusion: the mixture for the flower color is always dependent on the tone of the background.*

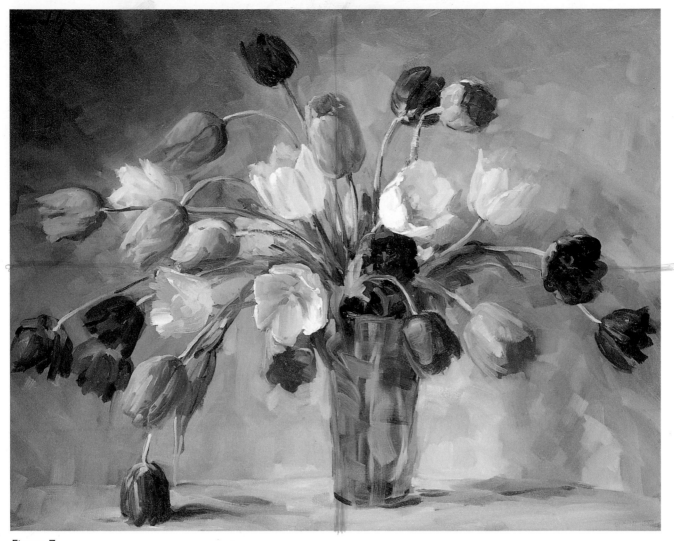

Figure 7.

place it on the side of the canvas that's close to the light so the larger space of background would be where the cast shadow would fall.

The background can be an interesting look of atmosphere or it can be a record of a texture, such as drapery or tapestry. It should be painted in a thickness and application that's consistent with the way the bouquet is painted: not thinly with thickly painted flowers; not smoothly with roughly painted flowers. Notice how different the two paintings of roses are *(Figures 8 & 9)*. It's due to the dissimilarity in the sizes of the backgrounds and also the tones and subjects of the two backgrounds.

Figure 7. The background of this tulip painting ranges from dark on the left (where the light comes from) to light on the right (where the light is going). Novice painters — and even some with more experience — are deluded into thinking that the canvas is light in the area where the light originates. You can see in this painting (and others in this book) that this conclusion is false.

*The black marks, painted on **Figures 8** & **9**, show the size of the bouquets in relation to the background and foreground. This should always be your initial consideration when painting your picture. Actually make marks on your canvas — such as the ones shown — so you'll be in control of the size of the bouquet on the canvas. How big you make it will be a strong influence on your picture's appearance. This should never be accidental.*

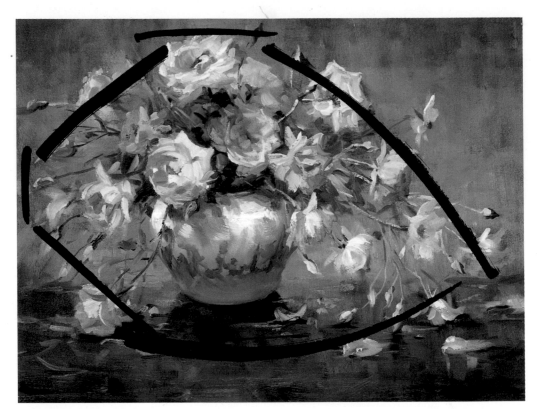

Figure 8.

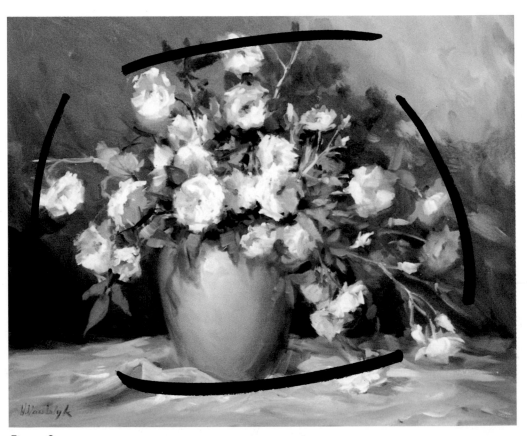

Figure 9.

The Difficulty of Foregrounds

The most difficult area to paint in a flower picture is the foreground because it's an area on the canvas that must record the dimension the canvas doesn't have — depth. The foreground meets the background, contains the bouquet and is in front of the vase. The foreground has to be an asset to the flowers without robbing the blossoms of their interest.

It's hard to relate the foreground to the flowers in a rhythm of application because the paint that records the flower is agitated by varying tones; the foreground is often a flat area of one tone. Its very plainness makes it seem separate from the mood of the flowers. One way to break up this plainness is to add some reflection to the surface and add petals that may have logically fallen off the flowers. Be careful, though, that you don't make them look contrived. Place them within the interest area of the picture, just as I did in *Figures 8 and 9*.

Paint the foreground with the same rhythm of application that you use to interpret the flowers. Don't let the size of your foreground be a chance event. You've got to plan on how much foreground you're going to have in your painting. You can make sure of this by marking off where the bottom of the vase is going to be in relation to the bottom edge of the canvas *(Figure 10)*.

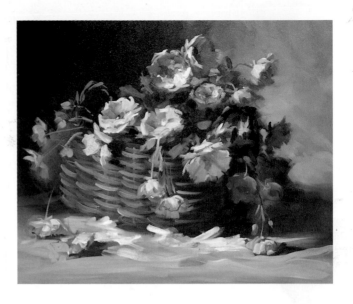

Figure 10. *Since the drooping flowers that touch the foreground are part of the composition, space for them had to be taken into consideration right at the start of the painting process. A line for the bottom of the vase was marked off as were lines to leave space for the drooping flowers. A good composition is always the result of some careful planning.*

These two diagrams show how a cast shadow from a bouquet can throw a canvas off balance or it can be used to balance the composition. Always put the cast shadow where you have more space for it. A cast shadow that falls off the canvas, such as in the left-hand diagram, drains the composition of its interest. Notice how the cast shadow on the right-hand diagram is more of an asset to the bouquet. Here's my general rule: always leave more background space on the cast shadow side of the canvas.

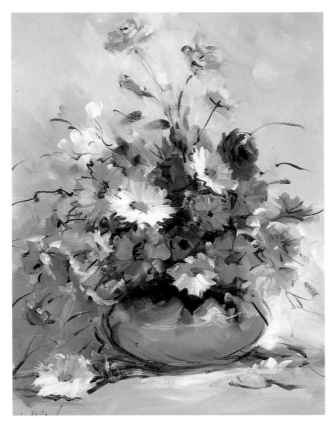

Unity, Variety and Balance. *The monotony of the shapes of flowers should be disguised. I did this by keeping some of them in shadow and making sure that the ones in the light were in slightly different positions and perspectives.*

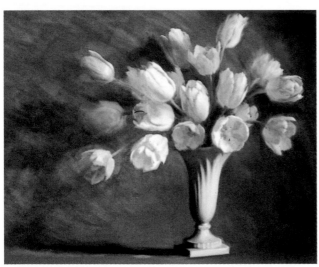

Overlapping. *My painting of tulips shows how none of the flowers just touch each other. They either overlap or are completely separate. Notice how the focal point in this painting is where the tulip is facing the viewer in the area of the lower right location. Remember, the all-important focal point can always be imposed in a flower arrangement by making a stark difference of contrast, position and shape.*

Variety of sizes. *A light background always exposes a more definite silhouette of the subjects, so more care has to be taken to make sure that the peripheries of the subjects are pleasant in relation to each other. When painting a subject against a dark background however* (as seen above), *much of the subject's outlines are obscured. Notice how the elements are different sizes.*

Harmony Through Repetition. *It's very difficult to make unrelated shapes harmonious, such as combining circles and squares. In this painting (above), a lot of circular objects have been used: the vase, the the cup and saucer, sugar bowl, spoons and the table. The focal point — the box that holds the little spoons — is the only prominent non-round object.*

Size of the Focal Point. *The focal point can be either a large area or a small one. This painting (left) shows how the focal point is the entire vase area.*

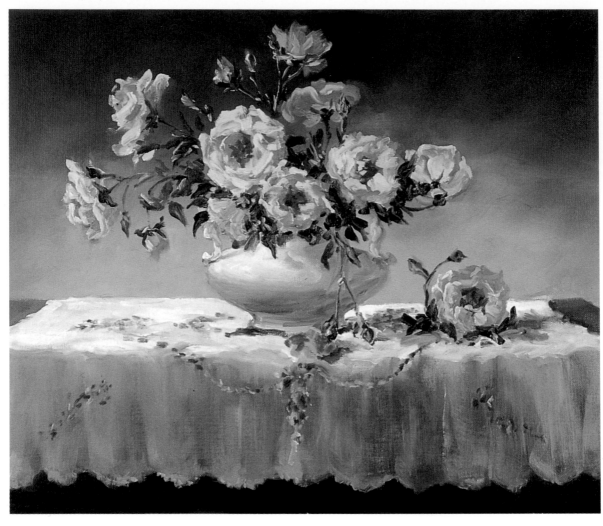

LES

 The Exception Makes the Rule

*Once all the rules of composition have been stressed, you don't have to follow them to the letter; they should serve to guide your artistic point of view. Look at how I broke the rules in this painting: the vase is in the middle of the canvas and the cloth is a square shape as opposed to the round flowers. I was aware of these transgressions; they certainly weren't accidental. But even breaking the basic rules, I felt that I had struck a balance: the square table balanced the round vase. This difference was unified by the central location of the vase on the canvas. The focal point, however, while quite near the center, is still in the upper left focal point area. Although rules were broken, many of them were still respected: **1)** I placed the flowers at different distances from the edges of the canvas. **2)** I overlapped the flowers or set them apart. **3)** 1 used the same free rhythm of application on the vase and cloth as I did on the flowers. **4)** I made the fallen flowers look plausible.*

Chapter 8
The Five
Tone Values

DIMENSION

The contrasts of light and dark not only determine your composition but also make the subject look three dimensional. Consider your lighting carefully. Once you realize that you are painting the effect of one source of light on your entire subject, you'll be on your way to painting a unified, natural-looking composition.

Lighting Your Focal Point

The five tone values all come together to record actuality. Think of lighting as a spotlight. The focal point would be the place where the light singles out an area, just as lighting on a stage. The spotlight is where the action takes place.

Arrange your lighting so you'll have contrast to use for composition and dimension. You can see this more graphically in the following pictured illustrations. *Figure 1* is the subject in flat light compared to *Figure 2* where the lighting is from the left. Notice that this causes cast shadows that pull the elements of the arrangement

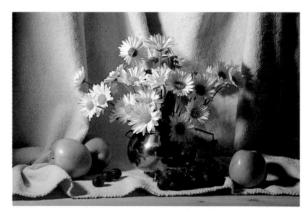

Figure 1.

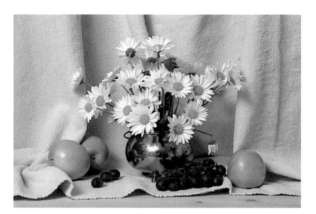

Figure 2.

*The painter uses lighting to make the painting process possible. He has to translate what he sees into five tone values. If he can't see these five values his pictorial effect of the subject becomes limited. Since reality, as we know it, includes the dimension of depth, our pictures can only look realistic if they record this dimension. A body tone, a body shadow and a cast shadow, are seen in **Figure 2**, because the lighting, coming from the left, is creating this dimension. If your lighting doesn't present these tones, (**Figure 1**, which is lighted from the front thus doing away with any existence of body tone, body shadow, cast shadow and highlight) the flatness of the canvas will be exaggerated.*

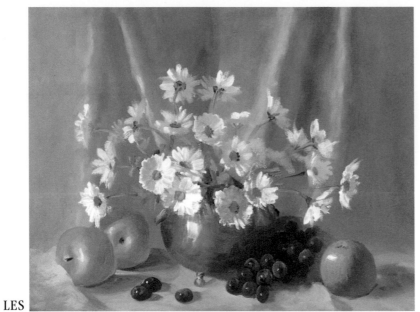

Figure 3.

Figure 4.

 Figure 3 is a painting of the arrangement shown on the previous page. It points out how it was seen in five values. The cast shadows make a pattern on the table as well as adding dimension; highlights make the grapes shine; and the folds of the drape are seen because of light and dark. Figure 4 shows how the impact of the lighting imposes a focal point and creates dimension.

together. In *Figure 3,* you can see how this arrangement was interpreted. The focal point is the area where the light was directly on the subject. Cast shadows are used to unify the elements, making it a composition of one arrangement rather than a composition of single, isolated things.

The painting of the flowers that are around the highlight of the vase is a good example of how a strong contrast causes a focal point *(Figure 4).* The flower facing us is light and is silhouetted against its dark surroundings.

Tone Value in Action

Let us analyze the tone values in the painting of petunias *(Figure 5)* to see how they perform for dimension and composition:

1. The cast shadow in the background balances the placement of the bouquet, and makes the bouquet stand away from the background.

2. The folds of the towel are recorded by: (A) a body tone; (B) a body shadow; (C) a cast shadow; (D) a reflection. These same tones appear on the vase along with a highlight (E) that shows the texture of china.

3. The petunias look as thought light is striking them because of the light and dark tones. The shape of these lights and darks shows the petunias' form.

1. Body Tones: All areas marked A; 2. Body Shadows: All areas marked B; 3. Cast Shadows: All areas marked C;
4. Reflections: All areas marked D; 5. The Highlight: Identified by E.

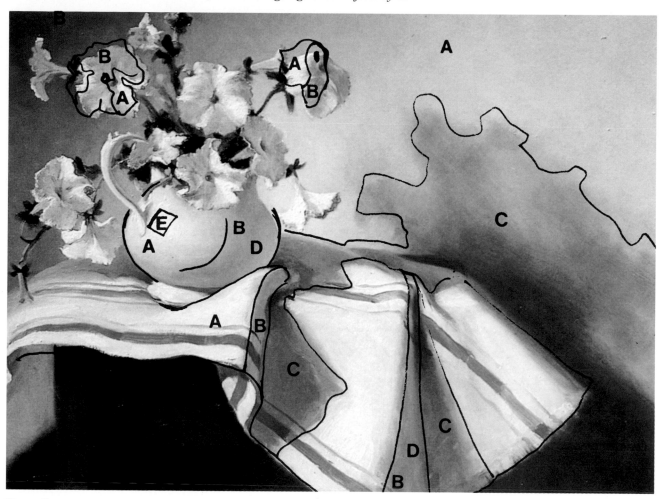

Figure 5.

The Highlight is a tone value that appears wherever the lighting strikes so directly that a lightest light — or seemingly colorless light — appears. A highlight should only be applied to further describe a plane's structure; it should never just decorate. These highlights appear where a subject "bulges" or "indents" in line with the light. A body tone (indicated by the straight line) is the plane toward the light. When this plane is either concave (dent) or convex (bulge), indicated by the arcs — a highlight appears (locations shown by the arrows). Make sure that the value of your body tone is dark enough to accommodate a lighter highlight.

Chapter 9

The Three
Factors of Drawing

PLAUSIBILITY

Let's see how the three factors of drawing — perspective, proportion and anatomy — can influence the final effect of a flower painting:

Perspective

Perspective, or the point of view you take, can surely change the composition. Your three options are *(Figure 1):*

1. *To look down on a bouquet.*
2. *To look straight ahead.*
3. *To place it higher than your eye level.*

Notice how different the views of the bouquet are. Looking down at it makes it look cozy compared to the elegance of the bouquet when it's viewed at eye level. An eye level view always makes the background more of a challenge but it also eliminates the problem of making the table look like it's in back of the vase. Looking up at a subject is seldom used because it's a theatrical point of view and not plausible in our everyday world. But it is an option.

Proportion

Proportion is a strong factor in pictorial effect, not only in the size you choose to make the painting but also in the size you decide to make the flowers. Whether you make them smaller than life, life-size or larger than life, it doesn't matter which one is your choice; the important thing about proportion is that all the elements of the picture must be the correct size in relation to each other. These sizes are influenced by perspective, as seen in *Figure 3.*

Figure 1. – Points of View.

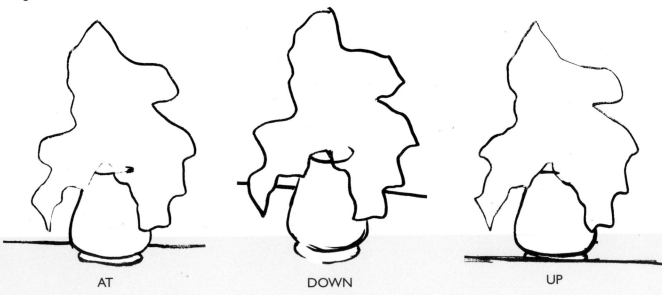

AT DOWN UP

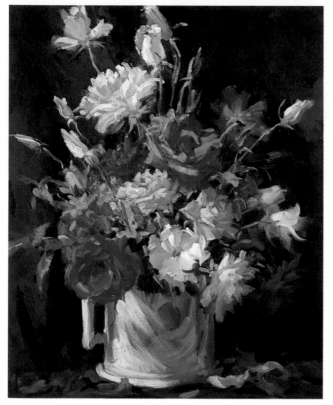

Figure 2.

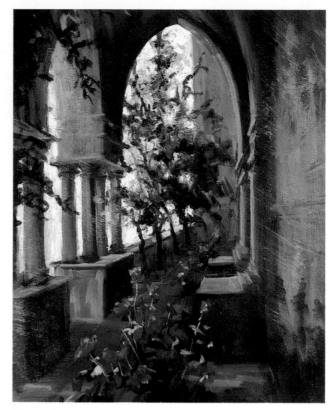

Figure 3.

Figure 2. The size of the arrangement in relation to the size of the canvas makes this an upfront view.
Figure 3. The red flowers in the foreground are in relation to the size of the arches and to the size of the canvas. Correct proportions are the secret to correct perspective.

In **Figure 2,** the size of the bouquet of roses is large compared to the size of the canvas but is in proportion to the size of the vase. The rose arrangement is approximately one-and-one-half times the size of the vase, a good proportion for flower arranging.

Anatomy

Anatomy deals with the structure of things. Just as you don't have to have a medical doctor's knowledge of muscles and bones to paint the human figure, you don't have to be a horticulturist to paint the structure of a flower. Be aware of the flower's structure as you look at its outer appearance. Look closely at the structures of various flowers. You'll find that the shapes can be classified as one or a combination of the

five basic shapes that are the foundation for every object in this world. These shapes are: cylinder, cone, cube, sphere and solid triangle. Applying these shapes to flowers, we find that many flowers are cylindrical and many are cones. While you may rarely find flowers that are shaped like cubes, very many can be likened to spheres.

See and paint the flowers' basic shapes before looking at and painting the petals. If you try to construct a flower with petals alone, they will look shallow. What it all comes down to is you can't see the forest for the trees.

The diagrams that are pictured in **Figure 4** show the basic shapes of flowers. How the light falls on these shapes will help you see flowers with a new understanding, one that you need in order to paint them validly.

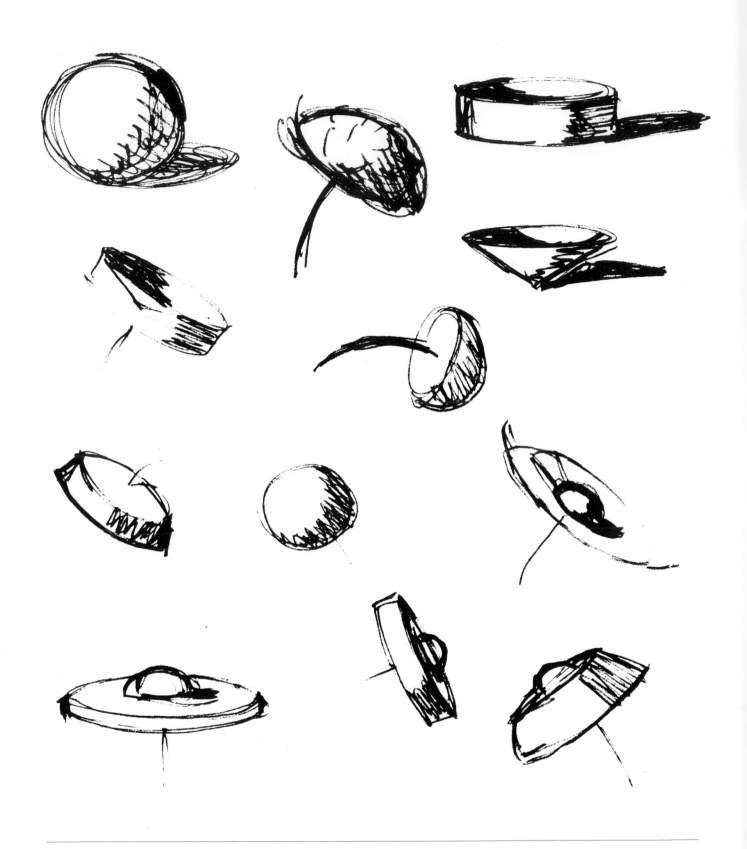

Figure 4. *These diagrams suggest the anatomy of flowers. Look beyond the petals and you will see the construction of all flowers in terms of these basic shapes: spheres, cones and cylinders.*

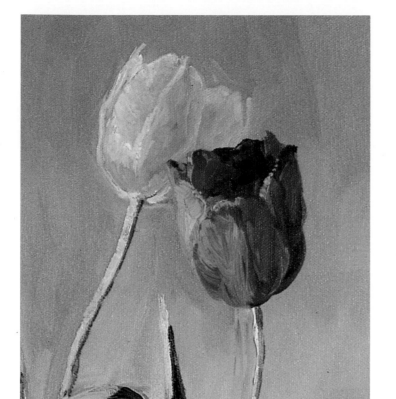

ANATOMY IN LINE AND DIMENSION

The correct record of a flower's anatomy depends on two things: the flower's silhouette and the flower's dimensional structure. The **silhouette** is recorded by a beautiful edge in contrast to its background. Its **dimensional structure** is completely dependent upon the tones on its form since most flowers are basic forms. These diagrams show the light and dark of the basic structure of the flowers; the flowers' more recognizable silhouettes are printed in magenta.

TULIPS

IRIS

SEEING FLOWERS
IN PLANES

1. The many little petals of **chrysan-
themums** grow in a pattern. The
entire bloom flattens at the top and
the petals grow in graduated rows.

2. Each unfolding layer of a **rose** is
made up of five petals. It's important
to show its core (the center) and
make sure that the petals unfold in
a series of ellipses.

3. In anatomy, **zinnias** are very
much like chrysanthemums except
that their petals don't curl. The
difference in their appearance will
rely mostly on the rhythm of appli-
cation you'll use to record the
petals. Their outer silhouette, too, is
quite different because of the shape
of the petals.

4. A **petunia** is made up of five
connected petals and because of
the petals' veins, they are very capri-
cious in shape. Don't let this feature
of a petunia's anatomy alter the fact
that this flower is basically shaped
like a cone.

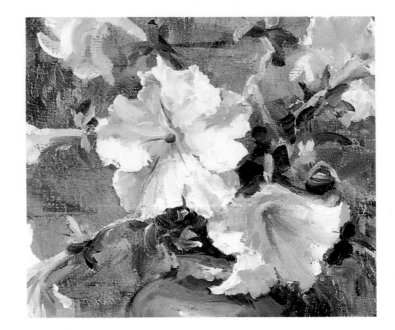

PETUNIA

ZINNIA

CHRYSANTHEMUM

ROSES

TONE VALUES FOR ROSES

The three basic tone values seen on a rose are body tone, body shadow and cast shadow. These are more readily recognizable if you analyze the rose's anatomy as shown on this page.

GETTING FLOWERS
IN DIFFERENT VIEWS

In these diagrams we see cylinders and cones in different perspectives to represent **daffodils** and **daisies.** These shapes in perspective present shapes that are called ellipses. which are the secrets to recording flowers in views other than head-on. Head-on flowers are the only ones that are round shaped.

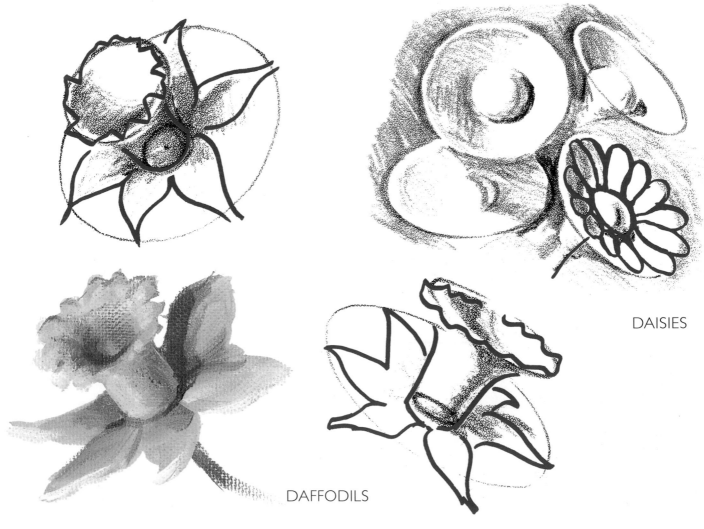

DAISIES

DAFFODILS

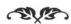

CLUSTER FLOWERS

Many flowers are a cluster of smaller blossoms. Don't let these little flowers hide the overall anatomy, as shown in geraniums. "A" shows the anatomy of the little blossoms. "B" shows that once you look beyond the little blossoms you'll see the entire bloom as a half sphere. A gladiolus is a spire of many flowers. Remember, the spire is a long cylinder and only the flowers on the light side of the cylinder can be illuminated. Many lilies are clusters of cones. Showing a flower's anatomy with tone value is just as important as showing the silhouette of their petals.

A.

B.

GERANIUMS

GLADIOLUS

LILIES

Chapter 10
Color in Light
and
Color in Shade

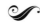

LUMINOSITY

Here is a basic, simple explanation of how light affects the color of subjects: the area of the object that's in light is painted in light tones and bright colors; the area of the object that's not facing the light (therefore it's in shadow) is painted with darkened tones and dulled colors. Since flowers are three dimensional, they have light tones where they face the light and darker tones where their shapes don't face the light. Let's translate this into paint terms:

The light areas of flowers are painted with colors that are mixed with white. The shadowed areas of flowers are painted with colors that are mixed with gray; in fact, they are grayed and darkened versions of the light color of the flowers.

Many novice painters think that color mixing is the most difficult thing to do in painting. Not so. What is difficult is finding in all the little piles of color on your palette the correct *tone* of the color. Color mixing does become easier if you focus more attention on the tone of the color that you see rather than looking at the color with a pre-conceived idea of what it is. Lighting alters a color's tone and its normal appearance. Look at what the lighting does to

a color and you're on your way to better color mixing. Complete color mixtures are given for every painting in the section that I call "Painting Sessions." In them, you'll notice that there is a strict use of cool colors and warm colors for each subject. There is a natural truth about light which dictates a discipline of use of color in painting. A beautiful phenomenon, it's easy to understand because it's so logical. It works this way (refer to *Figure 1* on the next page):

1. Where light strikes, the color appears and is warmed.
2. Where light can't strike, the color is obscured, darkened and cooled.
3. Wherever the light shines directly on the concave and convex planes, a highlight appears and it is cool.
4. Reflected light returns color into the shadow which is warm.

To appreciate and understand this logic: these tones of color present a warm and cool alternation of color that records luminosity. Cool highlights on a warm body tone; a cool shadow with warm reflected light.

Figure 1.

The Secret of Graying Color into Shadow

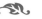 You have to develop your eye to recognize a true color or a grayed one. The secret of graying color is to add something into it that the color itself isn't. Therefore, warm colors are grayed with cool colors, cool colors are grayed with warm colors, as follows:

Yellow is a warm color.
Gray it with violet, its cool complement.

Orange is a warm color.
Gray it with blue, its cool complement

Red is a warm color.
Gray it with green, its cool complement.

Violet is a cool color.
Gray it with Burnt Umber, a yellow that's darker than the violet.

Blue is a cool color.
Gray it with Burnt Sienna, an orange that's darker than the blue.

Green is a cool color.
Gray it with Alizarin Crimson mixed with Grumbacher Red, a red that's darker than the green.

Because flowers have fragile, thin petals, the complementary color isn't used as strongly to make the petals fall into shadow. You'll find that this is due to the reflection of one petal on another and also on the thinness of the petals.

If you'd like to know more about mixing color, I strongly recommend my book, *Helen Van Wyk's Favorite Color Recipes*. This book, devoted more to the practical side of painting, contains color mixtures for more than 85 subjects, many of them flowers. It is published by Art Instruction Associates, Rockport, MA, and is distributed by North Light Books, Cincinnati, Ohio.

Light's Influence on Color

Body Tone — A warmed version of the color of the object, be it a ball, a vase or a flower.

Highlight — A very light, cooler version of the color, to the point of even being a complement of the body tone.

Turning Edge — Where hardly any color is visible. This extremely difficult area and color to paint is most successfully recorded by mixing black and white and the complement of the object's color in a darker value than the body tone, and painting this mixture in the shape of the shadow, fusing it with the body tone.

Body Shadow — A grayed, darker version of the body tone.

Reflection — A lighter area in the shadow that's colored by its surroundings.

Cast Shadow — Darker and duller than the body shadow and relatively complementary to the color it's on.

Edge of the Cast Shadow — A relatively complementary color to the background color.

Body Tone
Highlight
Turning Edge
Body Shadow
Reflection
Cast Shadow
Edge of the Cast Shadow

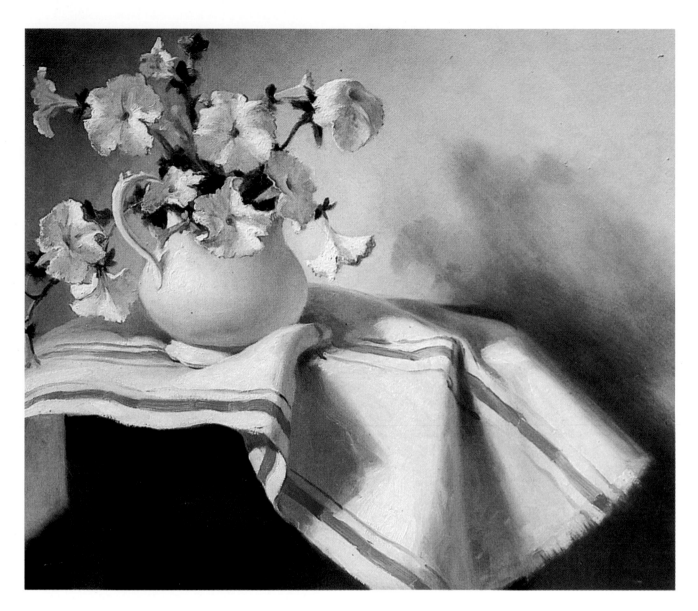

 Warm and Cool Alteration of Color in Action

This balance of color, so important to registering luminosity in your pictures, can be obtained by a strict observance of this color presentation. Wherever the light strikes (the body tone), the white of the background, cloth, vase and petunias are painted with a warm-toned white (black, white and Yellow Ochre). Wherever the turning edges are visible — the edge of the shadow on the vase, the edges of the shadows on the folds, the edges of the cast shadows on the background and the edges of the shadows on the petunias — the mixture is cool (black, white and Alizarin Crimson). As this color blends with the body tone, a gray appears; this is so characteristic of the edges of shadows. The insides of all these shadows — either body shadow or cast shadow — are warm again, thus you have warm body tones, cool edges and warm shadows throughout the entire painting. (Refer to page 63 for a diagram that analyzes all the tone values that I used throughout this painting.)

Found-and-Lost Line

ADDED DIMENSION

I often break down the painting process into three manipulations:

1. ***Rhythm of application.***
 Filling in areas of color.
2. ***The found line.***
 Abutting one color sharply against another.
3. ***The lost line.***
 Fusing one color softly into another color.

By knowing that these are the three basic things that have to be done with paint you'll be more in control of the painting process. Remember: the appearance of the paint is part of the beauty of a picture. Remember, too, that found-and-lost lines make shapes more dimensional.

Let's now examine the component that I call found-and-lost line: it is virtually impossible to paint a convincing three-dimensional flower without using both found-and-lost lines. These sharp and fuzzy edges are completely controlled by brushwork. A detail of one of my daisy paintings demonstrates why this is so. Notice the outer edges of the petals as they meet the background they are against. These edges record the shape of the flower and have to be considered carefully and painted in a clever way. The easy way is to have the background painted a little into the area where the flowers are situated so the stroking of the brush on the petals can move out into the background color thus forming the shape. Some of the

petals' shapes seem to blend into the background color and others sharply butt up against the background color. A fuzzy edge makes a petal look as though it goes back into the atmosphere of the painting. A sharp-edged petal looks as though it comes forward.

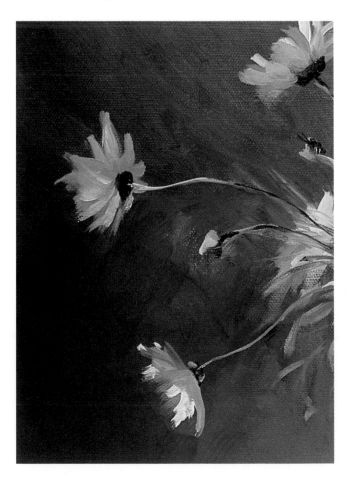

Projecting and Receding Petals

When you want a petal to look like it comes forward, start its shape from the outer edge and stroke in toward the flower's button. If, on the other hand, you want the form of the flower to recede, start the stroke of the petal at the button and pull the brush away from the canvas as the stroke comes out to the edge. The petal that is more forward should be painted with a loaded brush; the fuzzy petal that is farther back can be painted with a brush that has had the paint wiped off a bit with a rag.

 *Found-and-lost lines are controlled by brush handling. The sharp contrast (a found line) happens where the brushstroke begins. The lost edge happens where the brush is pulled away from the painting surface. In **Figure 1,** the stroking of the petals begins in the middle; in **Figure 2,** the end of the stroke makes a fuzzy edge (or lost line) as the petals' shapes meet the background tone.*

Figure 1.

Figure 2.

Painting Stems

Where you want stems to go back into the picture, drag a brush across the canvas in the direction in which the stem is going. Where you want the stem to jump out, paint it by dabbing its tone on with the edge of a wide brush.

Found-and-lost edges are just another factor to make subjects look as they do in reality. Keep in mind that reality is a matter of space and a painting is limited to a mere surface. The found-and-lost line helps to make space appear on that mere surface.

 *In **Figure 3**, the stroking of the petals starts at the background, making the petals meet the background sharply. This stroke is then pulled into the middle of the flower. To make a very sharp edge where you want it, make sure that the brush is loaded with a lot of paint. The brush could then be wiped and, as seen in **Figure 4**, stroked into this heavy paint to leave only a thickness where the found edges are needed.*

Figure 3.

LES

Figure 4.

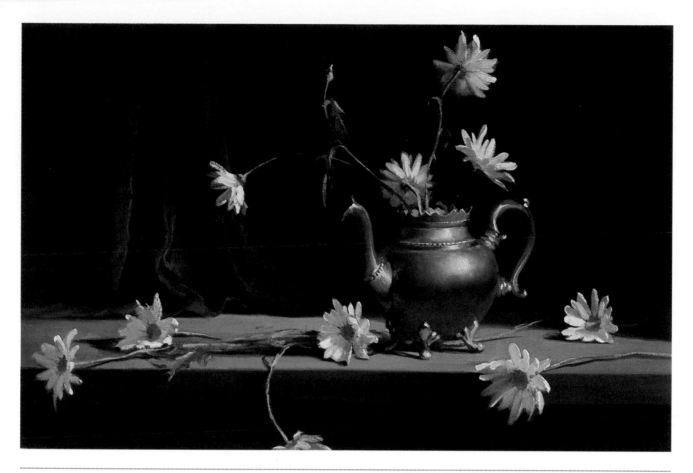

When painting you must always plan ahead. Paint all the edges "lost" first and then sharpen them up into "found" edges wherever you see them. Notice the found-and-lost lines on the teapot. Without lost lines it would look pasted against the background. The petals with lost edges were done with strokes that were started at the button of the flower. To show the sharper, overlapping petals, they were repainted with strokes starting at the edge and pulled into the button. Generally, sharp edges are made by starting the stroke at the outline of the object; fuzzy edges are started within the object's shape and eased out to the edges.

Color Mixtures

The Background Mass Tone: Black, white, Burnt Sienna, Burnt Umber.

Shadows on Background: Burnt Umber, Thalo Blue, touch of Alizarin Crimson.

Lighter Tones on Background: Black, white, Burnt Sienna.

Mass Tone on Pewter: Black, white, Burnt Umber, Yellow Ochre.

Shadows on Pewter: Black, white, Alizarin Crimson.

Reflections on Pewter: Black, white, Raw Sienna.

Highlight on Pewter: White and Manganese Violet. A lighter spot in the highlight of Yellow Ochre and white.

Stems: Sap Green with lighter tones of white, Sap Green and Cadmium Yellow Light.

Flowers' Mass Tone: Black, white, Yellow Ochre, Manganese Violet.

Lighter Petals: Yellow Ochre, white.

Buttons: Raw Sienna.

Table: Black, white, Burnt Sienna, Yellow Ochre.

Chapter 12
Rhythm
of
Application

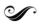

THE LOOK OF THE PAINT

Rhythm of application is the physical act of painting and is dictated by the look of the subject. Can you imagine painting with absolutely nothing in mind? No. Since painting is never done under this condition, rhythm of application becomes synonymous with painting. Paint, after all, takes on a look that's inspired by what you see, what you know and what you want. You activate the paint and it becomes a record of your feelings and thoughts of the subject. Maybe this is why it's so difficult to wipe off a mistake; it's like erasing yourself.

Paint's Many Moods

Rhythm of application strongly dictates the mood of a painting. Let's examine two paintings, "Cosmos" and "Petunias," to find out how this painting component influenced their appearances.

The painting of cosmos provokes a spirit of excitement while the one of petunias looks more serene. These contrasts in mood are primarily due to the brushstrokes in the backgrounds. What can you learn from this? When you arrange flowers for a possible painting, try to see them in terms of paint and the way that paint can be handled. There is a wide variety of appearances that paint can take on; its look

should be suggested by the subject which motivates rhythm of application. If you don't feel free to submit to the subject's suggestive appearance, you'll be apt to try to interpret it in a way that is strange and forced. Let your approach to the way you paint it give birth to a painting that has its own personality.

In the petunia picture, I responded to the quiet feeling that was suggested by the drooping of the flower and the hanging of the drape. These "down" forces send the message of tranquility even though the colors are quite exciting.

The Element of Time

A consequential influence on rhythm of application is the element of time. The cosmos picture was painted more quickly than the one of petunias, and it shows. If you want a spontaneous, loose interpretation, make sure that you don't have much time. You can never achieve this appearance when you're complacent about the time you have at your disposal. Don't ever disregard this factor in painting. While it's true that painting flowers provokes a pressure of painting time, it is the time that you give yourself to paint that dictates the rhythm of application.

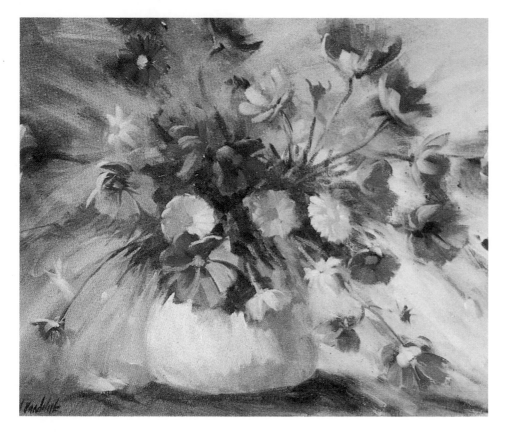

The correct color mixtures are completely dependent upon the tone of one mixture in relation to the tone of the background. In both paintings, the shadowed petals are darker than the background; the illuminated petals are lighter than the background. The shadowed petals: the color of the flowers mixed into gray. The illuminated petals: the flowers' color mixed into white.

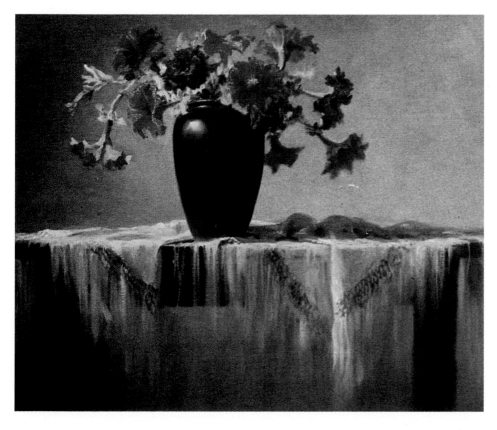

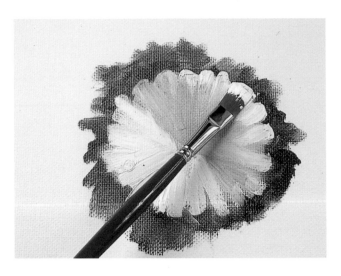
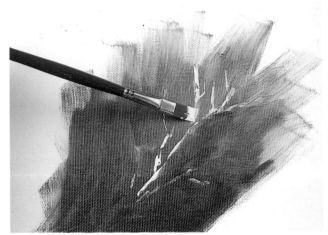

 There is a characteristic about oil paint that can't be influenced by rhythm of application: darks are thin, lights are thick. This makes you have to paint the darker tones first, saving the lighter tones for later. On the left, the lighter parts of the petals are being piled onto a darker mass tone. On the right, stems are being accentuated

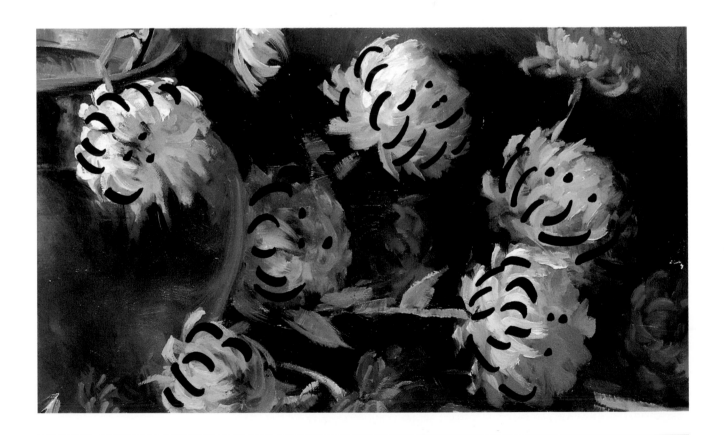

 The black lines indicate the rhythm that's suggested by these chrysanthemums. In order to have this rhythm show the flower's petals, save this rhythm of application for the more final stages of the painting process. Mass the flowers in first in a tone that shows their basic shape. Then, add lighter and darker petal strokes on top.

A rhythm is often suggested by the way you feel about light striking the subject. In this picture of daisies, the light from above causes a burst of cast shadows from the flowers on the table. Your progression of application greatly influences the appearance of the picture. The light background was painted in such a way that the dark silhouette of the flowers and the vase could be cut into this light-toned area.

The rhythm of the background was suggested by the texture of an old tapestry. All the colors of the tapestry were painted in first and then a mixture of Yellow Ochre, Raw Sienna and a touch of white was dragged across these colors with a large bristle brush. An interesting rhythm of application is most often done by adding an application to an already painted area. The lovely lights on the flowers were applications of white and Yellow Ochre added onto the already painted blooms.

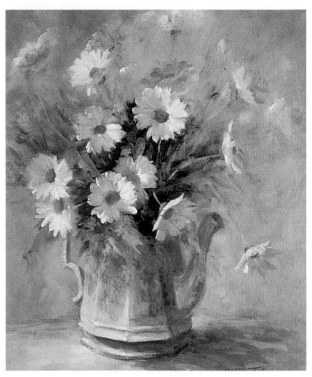

LES

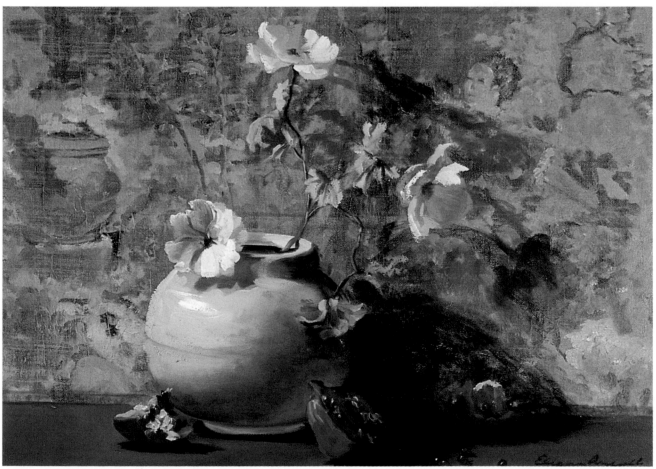

ED

83

Introduction to

Painting Sessions

❧

Painting a picture is made up of three vast areas of study and involvement:

1. Materials and how to use them.
2. Painting principles and their effect.
3. Procedure.

Now that you have read about the materials that I use for my paintings and, I hope, also learned about the principles that have guided me during my entire painting life, I'd like to invite you into my studio for a series of painting sessions to find out about the third phase of painting — procedure. I call this part of the book *Painting Sessions*. I want you to feel that you're with me in my studio. As I paint each picture, I'll describe what I'm doing.

Each *Painting Session* emphasizes the importance of a facet of painting. The difficulty of painting is completely eased by a practical step-by-step approach that will give you a chance to think of the problems of each phase one by one. The struggle is trying to make the final product look like your vision of it. Don't be discouraged if it doesn't turn out as you wanted it to be. *It never will*. That's what makes painting a lifelong intrigue.

So, welcome to my studio.

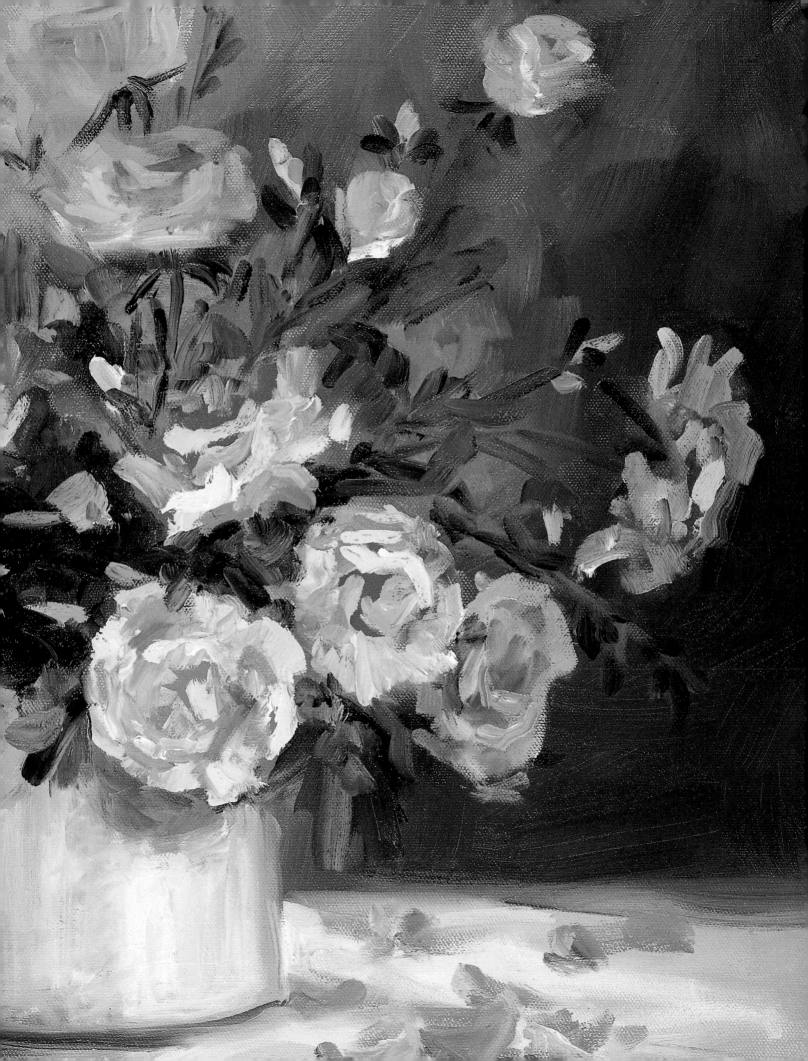

Placing the Subject

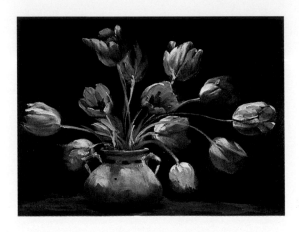

An effective way to teach is to stress what not to do. With this in mind, I'm going to start off this painting session with an emphatic **don't** for flower painting: *Don't ever start by drawing the vase in first!* You have no way of knowing how big the vase has to be to fit the canvas and still leave you enough space for the flowers. On the other hand, you may make the vase so small that you'd be left with too much background and foreground. Surely, you wouldn't buy a sofa before measuring the space where you're going to place it. Placement of the entire composition plays a prominent initial role in establishing a good composition. I call placing the subject "positioning the subject" and, as you know, position is everything in life. This painting session shows how I always place or position the subject on a canvas.

The Placement in a Painting of Tulips

Stage 1. I begin the picture of the tulips with my usual "four marks," made with Ivory Black diluted with turpentine. I put a mark at the top of the canvas to indicate how close the upper-most flower will be to the uppermost edge of the canvas. I put marks at the left and right of the canvas to show where I want the widest parts of the bouquet to be to the edges of the canvas and how I want to position the bouquet: to the left, to the right or even in the middle, if that's where I want it. Then I make a mark to determine where the bottom of the vase will be in relation to the bottom edge of the canvas. These marks are motivated by how big or how little I want the bouquet to be on the canvas. I never let the size of the bouquet be an accident. I want to show a round marble table in the tulip picture so the mark for the bottom of the vase is made with enough room left over for the table. I don't want to show much table in this composition, so the bottom mark is placed as low as I think it could be and still leave room for a little foreground.

Stage 2. Next, I draw lines to connect these marks to see how the silhouette of the subject looks on the canvas. Notice — I still haven't drawn in the vase. I put in a line to indicate the center line of the vase in the place that seems to balance the shape of the bouquet, and draw in the vase's shape to suit the arrangement of the flowers. Don't let the simplicity of this way to begin make you think that it is too elementary to use all the time. I use this simple beginning for every painting I do; I wouldn't dream of beginning to form my flower paintings without these guidelines. The success of a painting is a complex correlation of all the painting components.

Composition is a very important component and, fortunately, can be dealt with singularly. Placing and proportioning the subject on the canvas initiates the composition. One of my students astutely said that this step is like making an envelope to fit the letter that's inside.

Stage 3. All these compositional indications give me security to aim my paint with comparative ease. I like to call this the scaffolding on which my painting stands. Don't ever be afraid to make all these lines to place the subject well. You have to actually see how the composition is going to "sit" on the canvas. After these marks have served their purpose, they will all get covered up by the mass tones. It's silly to make an accurate drawing of the subject at this time because you're not making a drawing, you're beginning a painting. A bowl of cake batter doesn't look like a cake, but it will become one at the end of the baking process. People always remark about how free I am with my paint. I am, and you will be, too, only when you make it a practice to do one thing at a time. Don't compose and draw at the same time. Follow these steps before you begin to draw:

1. Place the composition in relation to the size of the canvas.
2. Make marks to see how the overall silhouette of the composition will look.
3. Indicate the proportion of the elements within the entire composition.

STAGE ONE

I always start with these four marks. They indicate how the outermost parts of the composition will meet the edges of the canvas. The mark at the top shows the uppermost tulip; it is higher than the one in the arrangement. The mark on the left shows where a tulip will be on the left of the composition. The mark on the right shows how there will be more space left on this side of the canvas. And the bottom mark shows the edge of the vase.

STAGE TWO

Many beginners are afraid to make this number of lines to indicate how the arrangement's going to look because they think that everything they do is going to show up in the finished product. Just as a house's framework doesn't show through the siding, these marks will be covered up by the painting process. These are guidelines to let you judge how your picture will eventually look in paint.

STAGE THREE

As you can see, the initial lay-in of the background tone, the vase and the table has covered up all the lines. In fact, this stage looks more unfinished than Stage 2. Remember, you're constructing a painting not filling color into a drawing as in a coloring book.

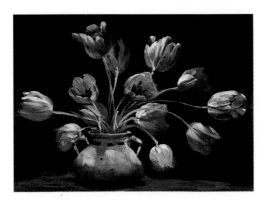

STAGE FOUR

The finished painting. Take a look at the initial marks in Stage One. Notice how I've honored them by keeping the absolute limits of the painted subjects at top, left, right and bottom.

Painting Session 2

A Basic Approach

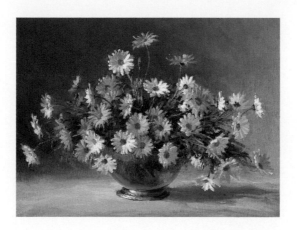

For every birthday, my husband Herb sends me a huge bunch of daisies — my favorite flower. And right after every birthday, I do a painting of them, no matter what else there is I have to do. I then name the painting after the year the flowers were sent, such as the subject of this chapter's demonstration, "Birthday Daisies '79." Daisies are actually in the mum family and are extremely hardy, which gave me a chance to take my good sweet time, a luxury I can't afford with more delicate flowers.

I painted this picture on a pleasant but cold day in April. I was at the easel from nine in the morning until four in the afternoon. The bouquet was a few days old and seemed to have a settled look. We had already enjoyed the bouquet of daisies as a centerpiece for the table during dinner with friends. Seeing them in this environment pro-voked me to paint them on a white foreground that would suggest a dining room table. I'd like to reconstruct that painting day in April to show you how I went about my work, or should I say my pleasure. I decided to paint this subject in a direct way.

ONE The bouquet was set up in my studio ready to be painted. I chose to have the light from my studio north window shine on the bouquet from the left, which I seem to prefer, putting me in good company with Rembrandt, Vermeer and scores of other great painters from the past who used this same kind of light source. After marking off the placement (as shown in Painting Session 1), I established the basic pattern of dark and light: a medium dark background with a light subject and foreground. I used a large brush and a thin mixture of gray, made of black, white and Burnt Umber. Some of the placement indications were still visible in the bouquet area at this stage of the painting.

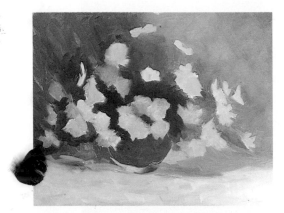

STAGE TWO Next, I painted in a warm light gray (black, white and Yellow Ochre) for all the white flowers, and a grayed yellow (white, Manganese Violet, Yellow Ochre and a touch of Cadmium Yellow Medium) for all the yellow flowers. I cut the background color in with a mixture of black, white, Thalo Blue and Burnt Umber to shape the actual silhouette of the bouquet. Where the greenery was most dense, I painted a dark gray-green of black, a little white, Thalo Green, Burnt Sienna and a touch of Alizarin Crimson. I also determined the shape of the bottom of the bouquet by massing in the vase.

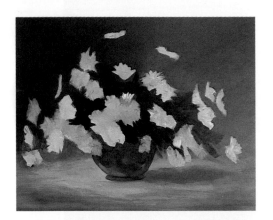

STAGE THREE The fun of actually making the masses look like flowers was started after the step, shown in Stage 2, was refined by painting the background again in warm grays (black, white and Burnt Umber) and cool grays (black, white and Thalo Blue). I painted the foreground with warm, light grays and more greenery. Notice the flower that I chose to "petalize" at this stage; it's the one that's farthest back in the cluster that constitutes my focal area.

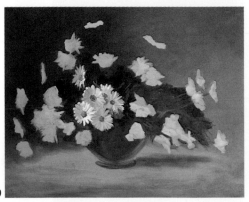

STAGE FOUR I began to develop the flowers. The flower on the very left of the focal point cluster was done last because it was the one closest to me. I used the following progression in the development of each area: the left of the bouquet, the right, and the top. I can't really hop around, painting any old one I want. I have to respect a progression that shows the flowers overlapping each other by actually painting one flower and then painting the one in front of it. Even the stems had to be painted in this sequence of back flowers first and forward ones second.

ED

STAGE FIVE To finish the painting, the flower planes that were absolutely facing the light were painted with a little bit of Yellow Ochre into white with no gray added. These lightest tone values were accented in the final stages of the painting. Save your accents of lightest and darkest tones for the finale.

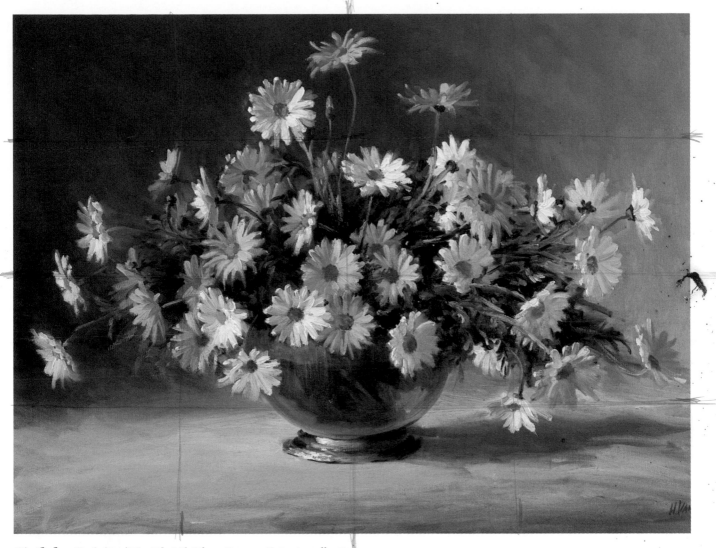

Birthday Daisies '79, *22"x 28", Oil on Canvas. Private collection.*

 We sometimes wonder what makes a painting successful.
Here are some of the contributing factors.

1. *The flowers that meet the background are not evenly spaced. This makes a pleasant silhouette.*
2. *All the flowers are either overlapping or by themselves. Not one of them just touches the other, giving each flower the advantage of a good position to show its shape.*
3. *All the flowers are painted with the same rhythm of application, making the bouquet look natural and unified.*
4. *I paid great respect to how lighting influenced the flowers' shapes.*

Painting Session 3

Seeing
the Subject
in Mass Tones

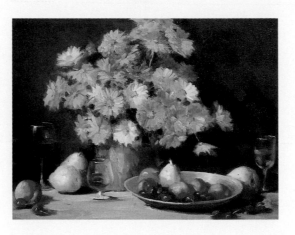

did this painting as a demonstration for a group
of students in my teaching studio. I used strong,
artificial lighting to dramatically show up the
pattern of light and dark. Since this light was
quite warm, all the colors were influenced. Even
the violet mums' color was warmed by the light-
ing. A cool color, such as violet, is warmed by
adding its complement, in this case Yellow Ochre,
mixed into a violet made of white, Thalo Red Rose
and Manganese Violet.

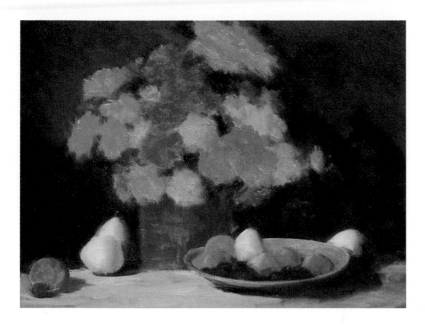

Color Notes

The color mixtures in Stage 1 are colors mixed into tones of gray. The color mixtures in Stage 2 are colors mixed into white.

Orange Mums: *Mass Tone – Burnt Sienna; Lighter Lights – Cadmium Orange.*

Violet Mums: *Mass Tone – Manganese Violet, Alizarin Crimson; Lighter Lights – Thalo Red Rose.*

Yellow Mums: *Mass Tone – Cadmium Yellow Medium; Lighter Lights – Cadmium Yellow Light.*

STAGE
ONE

After I established the composition I proceeded to translate the flowers on the canvas with mass tones. Many of my students didn't realize how important this stage of the painting was. It really is the foundation for the finishing touches. Few, if any of them, understood how long it takes to get the painting to this supposedly nebulous state. In fact, I had worked an entire morning — three hours — to reach this point; my students were surprised that it took so long. The difficulty about painting mass tones is holding yourself back from seeing and painting the actual appearance of the subject. There are no petals, no centers, no wine glasses, no highlights, nothing that will make the picture come into focus too fast. After all, when the picture's done it's done. Better to make sure the mass tones are a fertile bed for the subsequent development that finishes the picture. At this stage of the painting process, I stopped to stress how essential the appearance of the paint was. First, it was not thin; second, it recorded the basic composition and shapes; third, the tones were not very light or dark.

STAGE
TWO

The flowers' masses were then developed with lighter tones, leaving the mass tones where there were shadowed petals. These shadow patterns were accented with darker darks. The lighter and darker tones finished the picture. Try to imagine adding these lighter and darker tones to a canvas that has no mass tones. Many students think the mass tone stages are made with just mere washes of color or thin paint. Certainly this could be done but the appearance of paint wouldn't be as substantial. The final development of a painting never completely covers the mass tone stage. If it does, the contrasts of light and dark have no subtle gradation.

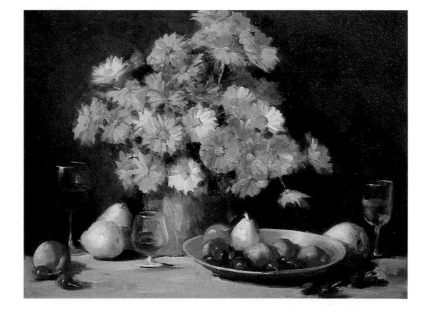

The Importance of Overlapping

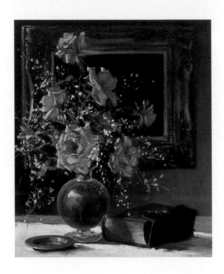

Knowing how much I love flowers, my friends send me bouquets to celebrate various occasions. One friend, in particular, always commemorates my return from a trip with a floral arrangement. The most recent one was a beautiful bouquet of laurel, baby's breath and five roses. The florist's geometrical arrangement, although pretty and quite creative, as florists' arrangements go, was not suitable as a subject for a painting. I pulled the roses out, put them in a different vase and surrounded them with subject matter that I thought would put them in a more natural, homey setting. I knew that in rearranging the roses I'd impose upon myself more of a painting problem than just flowers, background and foreground, but it was the composition that I wanted. My lighting once again came from the left—more concentrated this time than with the daisies in Painting Session 1 — by setting my subject matter closer to the window.

THE COMPOSITION

This set-up has a painting in the background. Only the frame of the painting was an essential element in the composition; the painting itself merely served as a dark background for the flowers. The old Dutch bible and the ashtray added interesting patterns to the foreground. Check with the finished painting and you will see a difference in the arrangement, the number of flowers and their placement. The featured rose is the full-blown one; the others serve to make up a bouquet. Troubled by how the surroundings monopolized the flowers, this was overcome by enlarging the flower arrangement, juggling the buds around in the process and even painting the same blossom twice, in different views, of course.

Stage 1. Starting with marks at the top, bottom and two sides of the canvas to indicate where the outer extremes of the composition would be in relation to the canvas size, the size and placement of the elements of the composition were roughly put in. Don't be afraid to mark off the sizes and placement with bold, authoritative marks. They give you an idea of the division of space; they are the guidelines for the mass tones. Black paint, thinned with turpentine, was used to make these marks, with the knowledge that they will become part of the mass tones. This artist never uses charcoal, personally believing that it's alien to oil paint; furthermore, unless charcoal is isolated with a fixative, it will in time dirty any light-colored paint that's applied over it.

Stage 2. You can see that all the guidelines have been covered and have become part of the mass tones. This was done by overlapping, in which an area of tone larger than it is so the succeeding contrasting tone can cut the preceding one down to size is painted. It worked this way: the background was painted in and overlapped into the shape of the frame. Then the frame color was painted out into the background area to show the shape of the frame by abutting its tone against the background. The mass tone of the frame was overlapped into the light insert of the frame. The insert color was then painted sharply against the frame color. The dark tone of the painting within the frame cut the insert down to the narrow shape that it actually was.

Overlapping of one tone into a shape so the subsequent shape can cut into the pre-painted area, gives you a lot of control over found-and-lost lines. To get a hard line, press hard on the brush that has the tone to shape into the painted area. Then, a more delicate touch will fuzz the shape into the pre-painted area. When painting a shape, never start at the so-called outline. Start within the form and move out with your stroke to form the edge. To be able to do this successfully, you have to forget that you ever had a pencil in your hand; never try to make your brush function as a pencil — it can't. As a painter, you are now an edge maker not a line maker.

The mass tones of the vase, book, ashtray and foreground were just suggested to cover the white canvas. The concern at this point was the flowers; it was imperative to get to them. The foreground, after all, would still be there tomorrow or the next day.

Stage 3. The background was refined by making it lighter on the right and darker on the left. (Refer to Chapter 8 to restudy and understand why the tonal arrangement just mentioned makes a picture look more dimensional.) Lighter tones were added to the frame to show the sculptured look and the texture of gold. The dark area that represents the picture in the

frame was darkened with some slight changes in tone to make it look like it was a painting of something instead of just a dark value. It had to be obscure otherwise it would have distracted from the roses which, after all, were the stars of the painting. Then the shape of the vase was formed by overlapping its tones over the background. When painting any colorless glass container, it must be done by recording the gray reflections that interrupt the values of the object or objects that it's up against or in front of. Make sure that these reflections are not as light as the highlights on the front planes of the vase that are in direct line with the light. (Refer to Chapter 8 to fully understand highlights.)

Once the elements of the background were done, some of the paint where each rose would be painted was carefully wiped away with a Turkish cloth, making sure not to wipe away areas that would be larger than the roses. By keeping them smaller the actual shape and size of the roses were cut out into the background, assuring the artist of nicely painted edges. To reiterate, rely on overlapping to sculpt shapes, either sharply or softly, successfully utilizing the advantage of the appearance that found-and-lost edges have on the look of the painted flower. At this juncture, show the form of the rose on the lower right with additions of light shapes and dark shapes to the mass tone.

Stage 4. The other roses received additions of lights and darks. The mixtures for the rose colors were:

1. **The Mass Tone:** *White, black, Cadmium Red Light, Alizarin Crimson, Light Red (English Red Light) and a touch of Sap Green.*

2. **The Lights:** *White, Grumbacher Red and a little Sap Green.*

3. **The Darks:** *More Light Red and Alizarin Crimson added into the mass tone.*

Stage 5. Now for the baby's breath. At this point of the painting care had to be taken because any baby's breath that looked oddly placed or any that weren't positioned well in relation to the roses would have to be wiped out and repainted. Moreover, any wiping out would most likely disturb the background. To play it safe, therefore, the pattern of the baby's breath was added in a tone that was just light enough to see and then accentuated with lighter tones. Finally, very light tones of Cadmium Red Light and white were added to the roses to show the extreme glare of light.

STAGE ONE The composition. This stage is the extremely important scaffolding for the painting. The dark marks, made with black paint thinned with turpentine, are the guidelines for the mass tones.

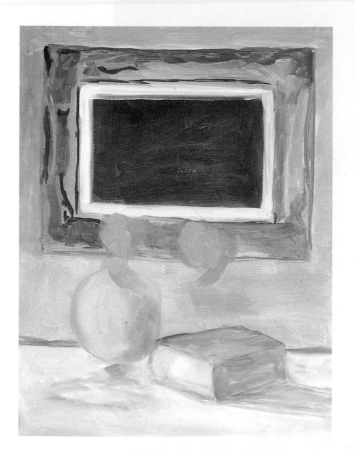

STAGE

TWO

This overlapping process is very important. The consistency of the paint at this time is often thought of as a thin wash instead of a strong covering amount of paint. If the overlapping process is inhibited by this thickness of paint, merely wipe away some of the excess with your rag. If this stage is painted too thinly it can never be corrected later since the development of the picture is painted on top of it.

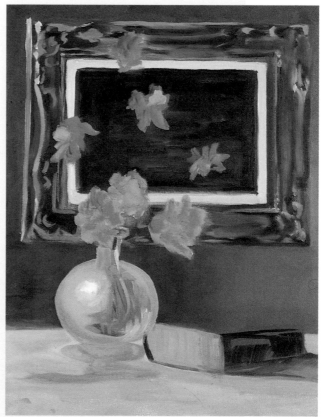

STAGE

THREE

Each stage of your painting should be executed well. A carefully structured procedure and progression will give you a chance to attend to each stage artistically and conscientiously.

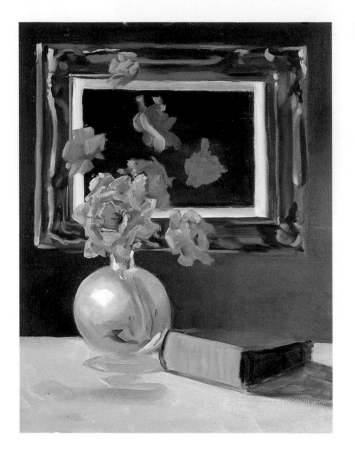

STAGE FOUR The advantage of working systematically is that each stage of development offers a new intrigue. The excitement is how you can make all the elements of the composition fit together. This excitement has to be saved for the final phase of the painting process. Don't be premature about this. Get it all done to the best of your ability and see how it looks before you paint with a critical eye.

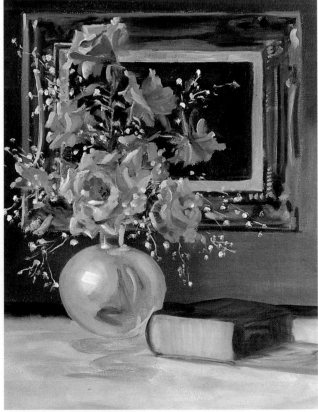

STAGE FIVE The way the flowers were painted dictated how the bible and ashtray would be finished. Make sure that your rhythm of application, or attitude of the paint, remains consistent even though you have to deal with the passage of time.

ED

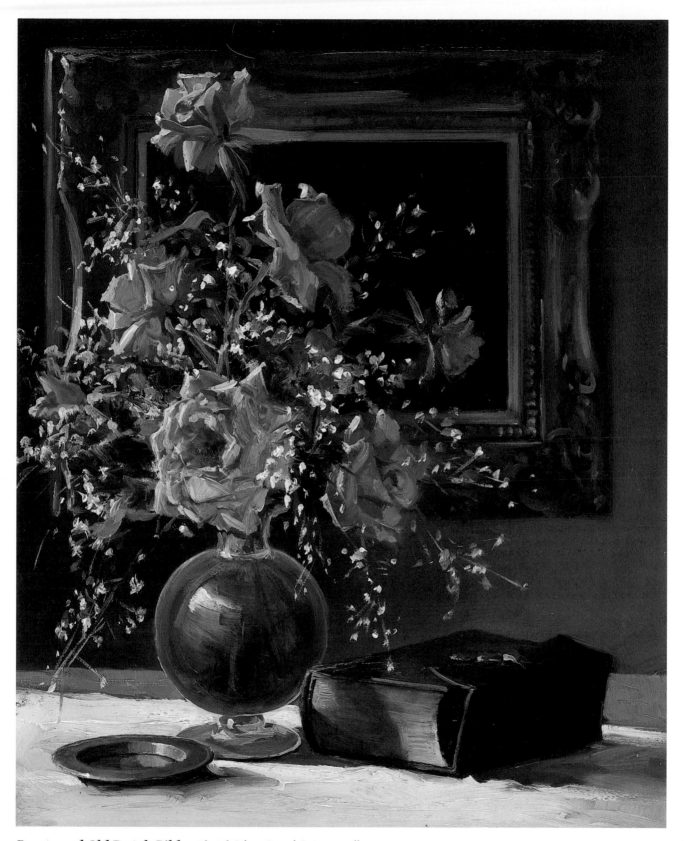

Roses and Old Dutch Bible, *11"x 14", Oil on Panel. Private collection.*

Glazing Color Over a Monochrome

A monochrome describes a picture that's made with varying tones of one color. Using a red rose as an example, if it's painted with tones made of red mixed with white, the picture of that rose will be a monochrome, not one in full color. Since light is made up of three colors (red, yellow and blue), yellow and blue must also be used to record the light on the red rose. These colors mixed make green, red's complementary color, which is necessary to gray the red wherever it looks muted and darker. A gray (black and white) monochromatic rendering of the tones of a composition is a sympathetic underpainting for any subsequent layers of color because gray is a general or common complement to any color. This rendering is called a monochrome and it is an extremely helpful and substantial beginning for the development of a painting.

Glazing color over a monochromatic underpainting is an old technique. It makes painting easier since it lets you think of the picture's development in three distinct stages:

1. The **underpainting** sets down the composition and mass tones.

2. The **glazing** then imparts color.

3. The subsequent **alla prima application** finishes the picture with accents of lights and darks.

Glazing color over a monochrome makes the picture a product of two thin coats of paint. I'm sure you know that even when painting a wall in your home it's better to paint it with two coats instead of one, especially if you're drastically changing the color. Oil paint only covers well when it's applied rather thickly which can make it unresponsive to subsequent applications and corrections.

There are certain instances when the glazing technique is extremely effective; one is when painting dark subjects. Dark colors that have no white in them are not thick and, therefore, do not cover well. Often, dark painted areas look thinly painted, which makes the picture look starved of paint. If the dark colors are glazed over the colors' dark values, the application looks richer.

Glazing the Mass Tones

I used this technique when I painted the wild asters. It helped me simplify the complexity of dealing with so many flowers and so many little petals. I glazed the background with Burnt Umber; the flowers with Manganese Violet and a touch of Alizarin Crimson; the copper can with Burnt Sienna. Then, the lighter tones were added where the light struck the flowers and the can.

The significant point to remember is that the underpainting should record the mass tones and the mass shadows, not the lighter lights. See in *Figure 1* how glazing over tones that are too light robs the chance to add lights to show the petals and texture. *Figure 2,* as you can easily see, is an underpainting that gives you a better chance over which to apply glazes.

What to Glaze With

You can glaze with all colors, and admixtures of colors, as long as they have no white mixed with them. The best medium to use to thin your colors for glazing is one made of equal parts of turpentine, damar varnish and linseed oil. Be careful not to make your glazes too thin; this is a common mistake among painters who are new to glazing. The result would be a color that would be too weak; too much of the gray underpainting will show through the color. At the other extreme, applying your glaze too thickly will cover the gray completely, which isn't right either because the gray underpainting must be allowed to contribute a lovely atmospheric effect that is characteristic of a grayed color.

FIGURE
ONE The hardest thing about doing an underpainting is to dissociate yourself from the appearance of the subject. After all, if you do your underpainting and it looks like a finished painting of the subject, as shown here, it can't function as an underpainting. You'll be afraid to work on it for fear that you will ruin "how pretty it is."

FIGURE **TWO** This underpainting shows you how the subject has been reduced to abstract patterns of light and dark. Doesn't this underpainting look like it would be an easier one to prepare you to paint the true appearance of the subject than the underpainting that's pictured in Figure 1? You can see the leeway that this offers you when you're ready to start to overpaint with color.

FIGURE **THREE** Here we see Burnt Umber glazed over the background and Manganese Violet and Alizarin Crimson glazed over the flower area. These are muted tones that are very receptive to becoming the shadowed tones when subsequent lighter lights are added. A gray underpainting stops you from having to mix tones of gray into your mass tones, as described in Painting Session 3.

FIGURE FOUR **The finished painting.** Glazes made this painting work. Aside from the glazes mentioned in Figure Three, Burnt Sienna was used to glaze the copper can. Finally, lighter tones were added where the light struck the flowers and can.

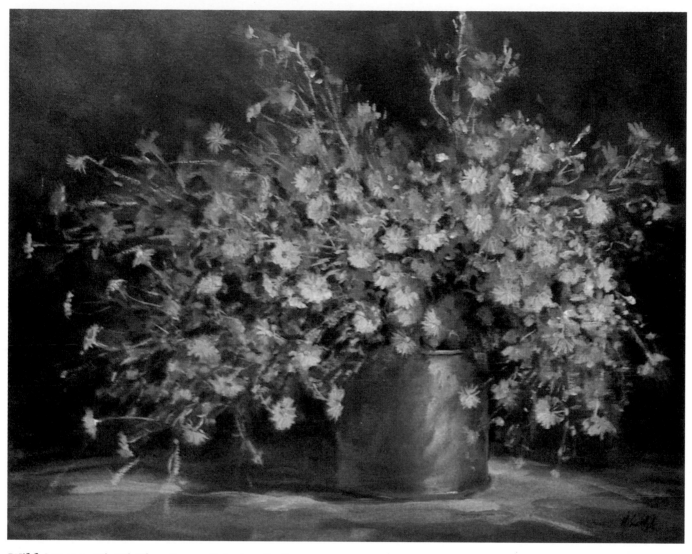

Wild Asters, *24"x 30", Oil on Canvas. Private collection.*

Painting Session 6

Underpainting to Regulate Thickness and Thinness of Paint

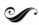

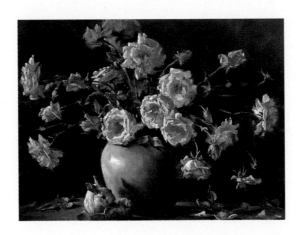

Since painting flowers is so much a matter of adding the appearance of petals by subsequent applications to mass tones, you can understand how advantageous it would be to be able to add these precious petal tones to mass tones that are not too thick. If the mass tones are painted thickly, the addition of these lighter tones that show the petals have to be applied very thickly so they are not swallowed up by the mass tone colors. A mass tone stage that is receptive to additional applications can be arrived at by glazing the mass tone colors over a monochromatic underpainting.

To appreciate the glazing technique in painting, you must accept the fact that contrast of tone, not color, is the structure of a picture. Just think about it, you can recognize every subject in this world by looking at a black-and-white photo of it. You can identify daisies, daffodils, roses, all the flowers. True, you can't see the color pink when you see the black-and-white print of the painting of roses, but you sure know that they're roses. You'll even know they're not dark red ones. Why? Because the tone value of the roses is too light to represent the dark tone of red. Once you realize that shapes, dimension, design, all the elements of a picture, are recorded by contrasts of tone, you can approach painting with tone value uppermost in your mind. Glazing is a word that is used to define the process of applying a transparent color to a pre-painted, dry tone to impart the glazed color to that tone. See how Alizarin Crimson that's been glazed over white makes the white tone light violet, and, in the neighboring swatch, Alizarin Crimson glazed over a dark gray makes a dark, rich, reddish violet *(Figure 1)*.

A glaze of color can only be applied onto a dry surface and the mixture must be transparent enough not to obscure the tone that it is applied over. This, then, absolutely rules out the use of white with any color that you're planning to use as a glaze. You know, of course, that once you add white to a mixture it is opaque *(Figure 2)*. Another basic rule about glazing is that a glaze over a tone always darkens that tone. Thus, the tones of an underpainting should be lighter than those actually seen in your subject.

I painted "Roses '79" *(Figure 4)* by glazing color over an underpainting. I established the initial phases of the picture in tones of black and white, using acrylic, a paint that dries quickly. Then, I applied glazes of oil color that imparted color to these tones. The paint on the canvas now was what it would have been had I painted the color and tone directly as one layer of paint, except the color layer was thin, transparent and very receptive to additions of subsequent layers. I added the lighter tones on the petals without any fear that the mass tone would be contaminated by the applications. Where I wanted a soft blending of the added color to the undertone, I pressed the edge of the lighter tone into the wet glaze with a brush that was wiped clean of excess paint.

Figure 3 shows the painting of roses in the phase of tones of black and white acrylic with a glaze of Light Red and a touch of Alizarin Crimson and Raw Sienna over some of the roses. A glaze of Burnt Umber was applied over the background tone. The vase and porcelain rabbit were glazed with thinned Thalo Blue.

When the picture was developed as much as possible with glazes, the lighter tones were added to show the light striking the petals, the vase and rabbit. The leaves and petals on the table were added to the finished foreground and the cast shadows were painted to show that the leaves and petals were lying on the table.

Many people confuse glazing with a ceramic glaze. The only similarity is that both add color, but in ceramics the glaze also adds texture, such as a shine. Glazing in oil painting only imparts color to a tone value.

FIGURE ONE On the left is Alizarin Crimson glazed over white; on the right is Alizarin Crimson glazed over gray. A glaze always darkens a value. A glaze over an underpainting is always a thinner mixture than an *alla prima* mixture. This is important because subsequent applications are always necessary. It's easier to put thick paint over thin paint than thick paint over thick paint.

A mixture of Alizarin Crimson and white. You can see that mixing white and Alizarin Crimson is not as luminous as the Alizarin Crimson glaze shown in *Figure 1*. Furthermore, this mixture is slow drying because of its thickness and of the amount of white in the mixture.

FIGURE **THREE** Shown here is the start of the glaze over the monochromatic underpainting that was prepared with tones of black and white acrylic. The fast-drying characteristic of acrylic is beneficial to the preparation of an underpainting; the artist can almost immediately begin to apply glazes. An under-painting that has been done with tones of oil paint grays, albeit painted thinly, would still require days to be completely dry.

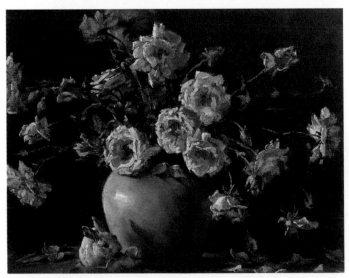

FIGURE **FOUR** **The finished painting.** When finished with accents of pure paint, as was done here, the end result has the look of a painting done in *alla prima*. The purpose of using glazes is not to produce a "glazed" painting but to arrive at the conclusion in an easier manner.

Roses '79, *16"x 20", Oil on Canvas. Private collection.*

FIVE

The three steps shown here will give you a good idea of how an underpainting functions as preparation for subsequent layers of glazes. The first shows the initial lay-in of the composition; the second pictures the start of the monochromatic underpainting; the third illustrates the beginning of the glazing stage. You can see here how important it is to get a good underpainting.

Step 1.

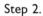
Step 2.

Step 3.

Color and Complement in Practice

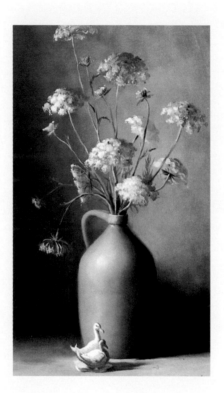

feel that it's vital to direct your careful attention to the importance of the juxtaposition of a color and its complement. This use of color must be learned because it is the factor that will make your paintings luminous and your colors look natural.

THE PRIMARY COLORS

Light, as we know it, is made up of the three primary colors — red, yellow and blue; we always see things under the influence of these primaries. To reproduce this fact in your painting you must use the three primaries because you paint objects as they are affected by this colorful light.

THE COMPLEMENTARY COLORS

A color and its complement are actually the three primary colors: two are mixed together to make a secondary color, such as: green (red's complement) is yellow and blue mixed; orange (blue's complement) is red and yellow mixed; and violet (yellow's complement) is red and blue mixed.

Warm and Cool Colors

Before we go on to examine how to apply these colors to record the subjects, I want you to be aware that the complement of a cool color is a warm one and the complement of a warm color is a cool one. Warm colors and cool colors show each other off. The use of warm colors and cool colors is a relative use of a color and its complement. Actually, there is no such thing as a muddy color; it's just one in an unfortunate place.

Using Colors and Their Complements

I can teach the use of a color and its complement more easily by pointing out the procedure that I used to paint "Queen Anne's Lace" *(Figure 1)*. The background is basically a yellow color that's interspersed with cooler yellows. To cool a yellow, add violet, yellow's complement. It's visible in the painting where the background falls into shadow. Inside the shadow, a dark yellow appears again because of reflected light. My use of a color and its complement applies to every single subject; it is a sound record of

the effect of light. It must be strictly obeyed to respect nature's rules that dictate the use of color in light and in shadow.

Let's now see how this applies to the vase. The mass tone was painted yellow (white, Burnt Umber and Yellow Ochre). I darkened this tone a little as it neared the point where the vase's shape withdrew into shadow (less white). At the very point where the shadow started, violet was used to shadow the yellow color (black, white and Alizarin Crimson in a tone much darker than the mass tone). Once this color seemed to turn the vase color into shadow (called the "turning point"), I added yellow to the shadow mixture of Burnt Umber and Raw Sienna to show that the inside of the shadow was affected by the general illumination in the room; this is called the "reflected light."

Highlights

The highlight was added to the mass tone in a mixture of white and violet (Alizarin Crimson). By using yellow's complement — violet — for the highlight, it gave the appearance of the lighting glaring away the vase's color. Highlights are always relatively complementary to the color of the objects they appear on.

Seeing Color in Light

The use of a color in conjunction with its complement becomes quite simple once you fully understand the fact that you do not paint the actual color of the object but rather the affect of the light upon that color. When subjects are painted with only the colors that they are, the paintings of them look flat and dead. As soon as the complement is used in juxtaposition with the color, however, the subject becomes luminous looking because it has been virtually created with paint the same way light created its actual appearance. Remember, light causes color; shadows reduce that color. A color's intensity is reduced or grayed by adding into it its complement.

Warm and Cool Alteration of Color

 Figure 1.

1. Cool: *Lighter accents in background*

2. Warm: *Mass tone background*

3. Cool: *Turning point of background shadow*

4. Warm: *Inside of the shadow*

5. Cool: *Edge of the cast shadow*

6. Warm: *Inside the cast shadow*

7. Cool: *The highlight on the jug*

8. Warm: *Mass tone on jug*

9. Cool: *Turning edge of shadow*

10. Warm: *Inside of the shadow*

11. Warm: *Table tone*

12. Cool: *Cast shadows*

13. Warm: *Mass tone flower*

14. Cool: *Edge of shadow on flower*

15. Warm: *Shadow on flower*

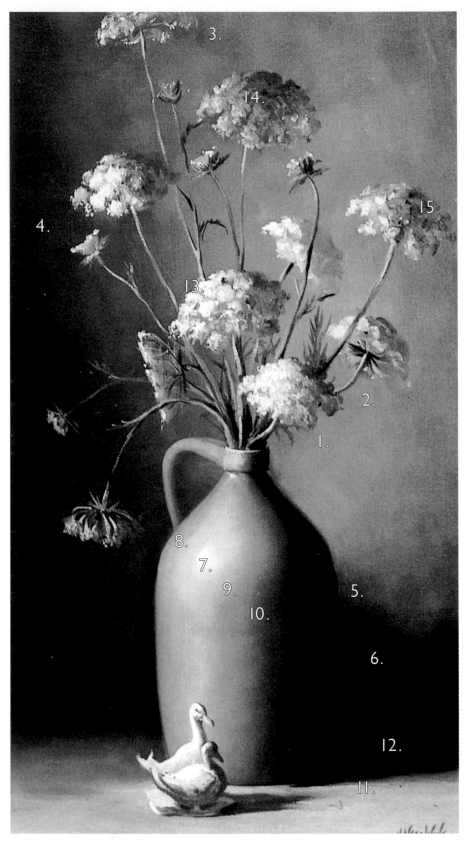

Queen Anne's Lace, *16"x 24", Oil on Canvas. Private collection.*

Painting Session 8

Flowers – Alla Prima

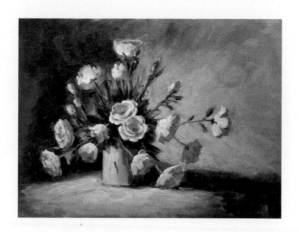

Alla prima is an Italian phrase that means "at the outset" (or, more to the point, "all at once"). It's easy to see, therefore, how it came to be used to describe a direct manner of painting, which means that shape, tone and color are all put down in one opaque application.

The stages of development of my *alla prima* painting of roses was photographed during an actual painting session. You may use this direct approach for any type of flower on any size canvas. When working *alla prima,* it's better to tone your canvas gray before you start. A white canvas is not as sympathetic as one with a gray tone. This picture was painted on a 20" x 24" canvas; painting time was about three hours.

The all-important placement on the canvas. Once again, four marks were used to indicate where the bouquet's silhouette would be near the edges of the canvas. Pay particular attention to the fact that only the placement of the flowers has been indicated; the actual shapes of the flowers have only been drawn in very sketchily, not enough to identify what they are.

STAGE
TWO Next, the shapes of the roses were massed in with the rose's color, which was made of white, Cadmium Red Light, Grumbacher Red and some Sap Green to tone the pink color down. It's easy to see here how using a toned canvas will enable you to be very direct and start with the mass tone of the roses. If this had been started with a white canvas, the tone of the roses would have been a dark tone on the white canvas.

STAGE
THREE Now for the greenery. Where its tone met the flowers, the greenery was used to shape the flowers. Remember the importance of overlapping shapes, as explained in Painting Session 4.

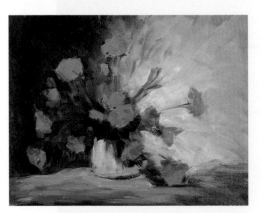

STAGE
FOUR The background was started in the lower right area where it was light and then continued with a gradation to a darker tone on the left side of the canvas. The background was painted into the area where the vase was and the foreground was also massed in. Then the vase, too, was massed in. It's important to prepare the area for the actual painting of a vase so it looks like it sits in front of the background and is in the atmosphere of the foreground. Consider this stage to be the most critical part of a painting's progress and one that is often done haphazardly by a beginner. The actual finished painting is implanted onto this paint layer.

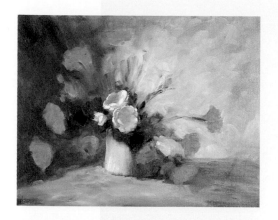

STAGE FIVE At this point, the subject was very carefully inspected for all the lighter tones that were caused by the direct lighting from the left. These lighter tones were added to the mass tones of the flowers, consigning the mass tones to become the shadowed part of the flowers. Never, at this stage, should you cover the entire mass tone with the light tone; you'll end up with just a lighter mass tone instead of the dimensional form of the flowers that appears because of the contrast of mass tone with added lights.

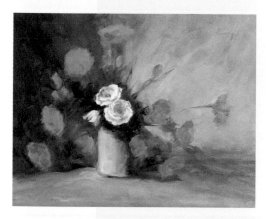

STAGE SIX The three flowers in the focal area have been finished. It's a good idea to start at the focal area, then you can relate the remaining flowers to it. Remember, the focal point is always supported by the areas that remain.

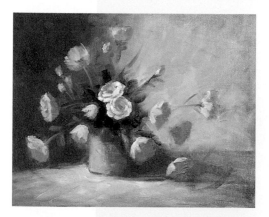

STAGE SEVEN Some more of the flowers were developed and some definition was added to the greenery. It is important to do one thing at a time. While it's so tempting to want to work on the entire picture as you go, you must respect the evolution of the painting as you apply layer upon layer of "completeness."

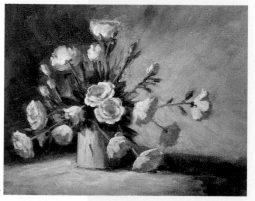

STAGE EIGHT The picture was finished when lights to the vase and the foreground were added, and the greenery got some accents of dark and light. The painting process is a thinking process, not a feeling one. I know this may sound a bit cold-blooded, but if you try to paint what you feel instead of painting what you think about, you'll sacrifice composition, proportion, anatomy, tone, color and rhythm of application, the very elements of the painting process.

LDG

Lilacs –
Their Color
and Petals

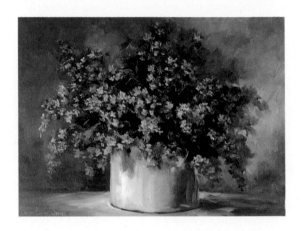

I n Rockport, where the aroma of lilacs perfumes the entire town, there are virtually trees of them, many that are taller than the houses. For this Painting Session, I was lured to the challenge of a bouquet of violet lilacs even though white ones would have been easier to paint: they can be painted against any colored background. Furthermore, white lilacs are very light in value and can be painted against any value of background except, of course, white. Violet, on the other hand, is limited to a choice of two tones of backgrounds — very light or very dark — because violet itself is medium in tone. Lilacs of any color are difficult to paint because of all the little flowers that make up the entire bloom.

VIOLET COLORS

If you want to paint violet flowers, make sure you have all the violet colors you can find:

1. ***Alizarin Crimson*** *is a must. It is a bright red violet when mixed with white. Many tones and intensities of violet can be made from Alizarin Crimson when it is mixed with black and white.*

2. ***Thalo Red Rose*** *and white make even brighter violets. A touch of blue when added to the mixture can tip its hue to a bluish violet.*

3. ***Manganese Violet*** *is good to have on your palette whenever you have to tussle with a violet flower. It makes a beautiful dark, rich blue-violet when mixed with Alizarin Crimson. Mixed with Burnt Umber, it makes muted shadow tones.*

Choosing a Background

Back to my painting of lilacs. I coped with violet's limitations by using a very dark background to keep me from putting a lot of white into violet for the lighter toned flowers. (Most violet colored paints lose their intensity when mixed with too much white.) I didn't use green in my background because of the leaf color; dark blue or red would steal interest from the violet and would present a cool interpretation. Therefore, through the process of elimination, I chose brown as my background color; it was the color that I thought would be easier to use to show up the lilacs' color. After all, brown is a form of yellow, which is violet's complement. Brown was also warm. I preferred this because I seem to see and feel comfortable in a warm world rather than a cool one.

"Petalizing" the Blooms

There are many flowers that are like lilacs in that their blooms are made up of many little flowers: hyacinths, geraniums, phlox, to name a few. The complexity of these kinds of flowers necessitates more than one layer of paint. Oil paint must be used in a progression of layers that begins with fast-drying colors and ends with slow-drying colors. White is the slowest drying oil paint and any color that's mixed with it will be slow drying. Colors with a lot of white, therefore, must be subsequent applications not initial ones; this is one of the reasons why the oil painter has to work from dark to light. The character of oil paint makes us have to ignore what we are accustomed to doing with a pencil or pen — that of making dark marks on a light surface — and reverse our way of working by making light marks on a dark surface.

Wet Onto Wet

Let's look at lilacs in terms of shapes of lights instead of shapes of darks. The lilacs in ***Figure 1*** are light shapes on a dark background. You can also see in this painting detail the many little flowers that make up the entire bloom and see them as light blobs of paint on a medium-toned shape of the bloom. Painting is seeing the subject in paint and its capability. In oil paint, it's easier to dab on little, light shapes to form the little four-petaled flowers of a lilac than to try to outline them with dark lines. Light-toned colors are thicker than darker toned colors because there's more white in the mixtures. It's easier to apply thick paint on top of thin paint. This is often called "wet into wet" painting. It would be better — and more descriptive — to define it as wet *onto* wet.

A painting is the sum total of many brush-strokes, and it stands to reason that the most meaningful ones should be saved for last. The entire lilac bloom can be painted with a rhythm of dabs that merely suggest all the little flowers. A few carefully applied dabs that accurately record one little flower can make the entire rhythm look like flowers too, somewhat like being guilty by association.

FIGURE ONE A careful observation and analysis of the characteristic of flowers are essential prerequisites to painting them well. If your observation of lilacs is superficial, your interpretation might look like many meaningless blobs of violet paint instead of a presentation of the bloom's anatomy.

FIGURE TWO Only after the placement, the composition and general mass tones of the background and bouquet, can you begin to have the fun of actually painting the little spots of light paint that put the subject into focus.

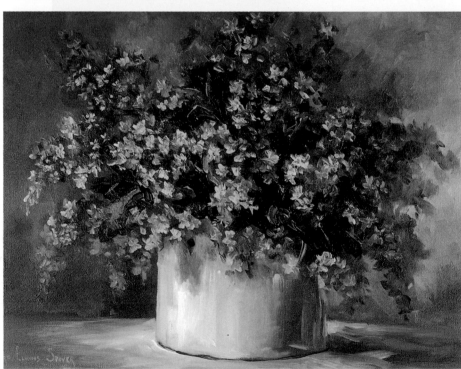

LES

"What do I Mix to Get . . .

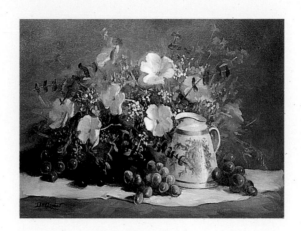

T he seven components to Helen were the sustenance that generated her career as a painter and which made her the popular teacher and television personality she became. The seven components, which have been thoroughly explained throughout this book, were the working parts of the principles of painting that Helen practiced and espoused.

PRINCIPLES, PRINCIPLES, PRINCIPLES!

As an adjunct to her teaching program, Helen began to use a technique which she had earlier tried in magazine articles, under the title, "What Do I Mix to Get?..." While it was true that this type of instruction bordered on teaching by formula, the popularity of the articles forced her to take a second look at this way of teaching color mixing. She liked what she saw, because along with these color-mixing formulas, there was enough emphasis on the all-important principles, and the attendant procedures, to make the project respectable in her own eyes, palatable for her own tastes.

A BIBLE OF RECIPES

These color-mixing lessons (which Helen whimsically called "recipes") eventually became *Helen Van Wyk's Favorite Color Recipes,* a copiously illustrated collection of color mixtures in still life, floral, portrait and landscape subjects, written in cookbook recipe format. Helen was proud of this work, especially when so many of her readers referred to it as their bible. *(Published by Art Instruction Associates and distributed by North Light Books, the best-selling* Helen Van Wyk's Favorite Color Recipes *is presently available at book sellers everywhere.)*

We have now come to the end of *this* book,

confident that the instruction that has brought us to this point will prove to be beneficial once you've applied it to your next flower painting.

For this final chapter, we've selected the color mixtures for fifteen flowers that are recognized as ones artists would most like to paint. The text is based on Helen's concepts; the illustrations for these flowers have been prepared especially for us by our three Tuesday Ladies, whose artistic contribution throughout this revised edition has been invaluable.

1. Baby's Breath

A bouquet of flowers looks lovely when clusters of baby's breath are added; they soften the effect. You can get the same softening when you add them to a painting. Caution — baby's breath should be added only when the painting is almost completed.

To add baby's breath: make a warm gray with black, white and Burnt Umber to a value just a shade lighter or darker than the arrangement (light against dark, dark against light). Using a little painting medium (made of equal parts of turpentine, linseed oil and damar varnish), start with a fine brush and paint in the stems of the baby's breath. Place them in quiet spots, radiating from the center of the arrangement. Then, with a thicker mixture of black, white and Burnt Umber (and maybe a little Yellow Ochre), paint in the little flowers with your brush, making dull, small masses and a few dots. Be sure these dots are in scale with your painting.

Once you feel that the placement of the baby's breath is right, you're ready to add the lights which is done with a mixture of white, Yellow Ochre and a little Burnt Umber. Place these lights on the small flowers and a few stems only where the light could hit them. Vary the size and shapes and place some lights in a cluster so they do not look like confetti. Don't forget to leave some in shadow. Another caution: adding these little flowers could get out of hand; don't over do it.

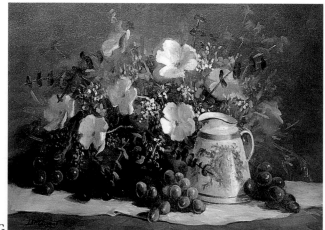

LDG

1. Baby's Breath

2. Chrysanthemums

We are dealing here with the type of chrysanthemum whose petal is gold at bottom and red at top.

1. Mass in the shape of the chrysanthemum with Light Red (English Red Light) mixed with Alizarin Crimson. This mixture should be more toward rust than red. At this point, do not do the straggly petals. Furthermore, don't apply the paint too thickly.

2. Mix a lot of Yellow Ochre into the basic tone and add strokes to indicate the petals. Use this mixture also for the straggly petals.

3. Use Yellow Ochre and white for the petals that have their undersides turned toward the light. Load the brush and press the paint at the point where the petal ends; twist the brush as you stroke toward the petal where it's growing from the flower, using a hook-shaped stroke.

4. Mix Alizarin Crimson and a little Ivory Black into Yellow Ochre where the yellow undersides fall into shadow. For any dark red areas that you see, use Alizarin Crimson with a touch of Burnt Umber.

5. Finally, Venetian Red and a little Cadmium Red Light for where the light strikes the red part of the petals.

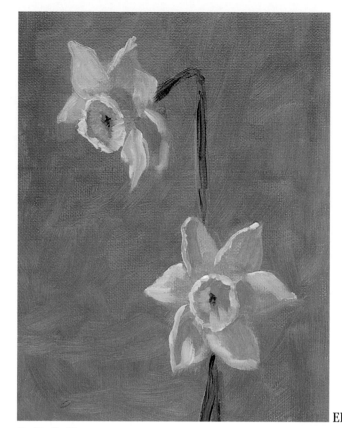

ED

3. Daffodils

3. Daffodils

To start out, it's best to have for any yellow flower you want to paint the following on your palette: Zinc or Lemon Yellow; Cadmium Yellow Light; Cadmium Yellow Medium; Cadmium Yellow Orange; Yellow Ochre.

1. With a mixture of Cadmium Yellow Medium and a little Yellow Ochre, mass in the silhouette of the daffodil. Add a little Ivory Black and Alizarin Crimson into this mixture for the body shadows.

2. Clean your brush and then mix a new puddle of Cadmium Yellow Light and some white to the light areas of the flower.

3. Cadmium Yellow Medium can be used for reflections in the shadows.

It's important to note that when painting flowers make sure that the mass tone always records the particular shape of the flower.

LES

2. Chrysanthemums

4. Daisies

1. The subject here is the white variety of daisies. To paint any white object, you have to paint it with a mixture of "off white": mix a pale gray of Ivory Black, white and Yellow Ochre to look like dirty white curtains. Use this mixture to mass in your flowers. At this juncture, make no indication of any details. Vary the way your daisies sit in the arrangement with daisies that face you (these will be round) and those that face to the left, the right and the top (these will be elliptical). If there are daisies that are bunched together, then mass in their entire silhouette.

2. You're ready now to add the real white of the daisies. This shows up in contrast to the off-white that it's being applied over. Into a lot of white, mix a small amount of Yellow Ochre. Loading a round bristle brush with this mixture, look for the petals that are lighter than the off-white mass tone. If the edge of the petal is coming toward you, start there and pull your brush into the center of the flower—the button area. However, if the petal's going away from you, start your stroke at the flower's button and let the stroke trail off as it reaches the end of the petal. *(See pages 77 and 78.)*

3. To complete the flower: you may need some darks made of Ivory Black, white, Alizarin Crimson and a little Yellow Ochre. Don't forget to add the button with Raw Sienna.

ED

5. Geraniums

5. Geraniums

When painting these hardy, colorful flowers, you'll find that the leaves are harder to do than the blossoms.

Ready? Let's start with the flowers. You'll need these reds to paint them: Alizarin Crimson (really a violet, but in this case, where it will be mixed with other reds, it can be considered a red); Grumbacher Red; Cadmium Red Light; Thalo Red Rose.

1. With Alizarin Crimson and Grumbacher Red, mass in the blossom.

2. Mix Grumbacher Red and white and add the lights.

3. A mixture of Grumbacher Red, Cadmium Red Light and white to go even lighter.

4. To the mixture in Step 1, add a little Chromium Oxide Green and use it for the shadow area. Use pure Alizarin Crimson for the darkest darks.

LES

4. Daisies

Now we're ready for the leaves:

5. We mass in the leaves with a mix of Chromium Oxide Green and Yellow Ochre.

6. Add Thalo Green and Burnt Umber to the mixture in Step 5 to paint darker leaves.

7. For the shadows on the green leaves add Alizarin Crimson and Ivory Black to the mixture in the previous step.

8. To Step 5, add Thalo Yellow Green and some white to lighten and brighten the leaves.

9. For any bit of gray that you see on the green leaves, apply a mixture of Ivory Black, white and Alizarin Crimson.

6. Japanese Lanterns

A large bunch of Japanese lanterns in a vase makes an exquisite arrangement and also presents a challenge to paint. When painting a picture of these lanterns, use either a very light or very dark background to show off to best advantage their red-orange color.

1. The mass-tone color: Cadmium Red Light with some Grumbacher Red in an application of paint that's not too thick.

2. Where you see the lantern lighter, paint it with a thicker amount of Cadmium Red Light and Cadmium Orange in strokes that are perpendicular to the very distinctive ribs that run from the stem end of the lantern to its bottom. This application is necessary to show the definite flat planes between the ribs.

3. Mix a little Viridian into the mass-tone mixture and paint in the shadows. You may have to darken this mixture with Alizarin Crimson for the darkest accents.

4. Sometimes Cadmium Orange with a little white can be added to the areas that are the very lightest—the highlights.

5. For the branches, use a mixture of Burnt Umber and Thalo Yellow Green. Certain sections of the branches may catch quite a bit of light. In that case, use Thalo Yellow Green and

a little white if the branch looks greenish. Or use Cadmium Orange, Burnt Sienna and white if it looks orange. To attach the lanterns to the branches, use a fine brush for the small stem that joins the lantern to the branch. Make sure these little stems go directly and straight into the middle of the indentation at the top of the lantern.

Important: Observe the branches of the Japanese lantern. You'll notice that they're made up of absolutely straight sections from lantern to lantern. Don't draw with curved lines; make straight strokes for each section from lantern to lantern.

ED

6. Japanese Lanterns

7. Lilacs

Lilacs of any color are difficult to paint. Violet ones, however, spell deep trouble because this color is one of the hardest ones to paint. So — make a hard job easy; try this painting challenge either on a very, very light background or on a very, very dark background. There's no "mister in-between."

Against a light background, your violet will look vivid if you use violet mixtures that are dark in contrast to the background. Using a dark background will prevent you from having to lighten your violet colors to the point that you will get a chalky condition.

Here are the tubed colors that you will

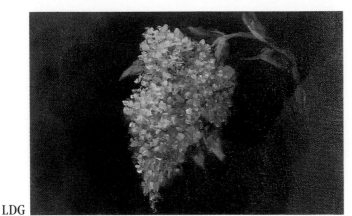

LDG

7. Lilacs

2. Make sure these three massed-in areas are painted with adequate paint (not a thin wash). Where the flowers meet the leaves and where they all meet the background, the edges should be fuzzy rather than sharp outlines.

Fuzzing tip: With your biggest, softest brush, lightly stroke across the canvas, starting from one edge and moving to the other. Then, do the same from top to bottom.

3. Add shadows to the flowers by mixing a touch of Alizarin Crimson and Ivory Black into your yellow mass-tone color; mix Cobalt Blue and Ivory Black into your orange mass-tone color.

4. Add lighter, brighter orange or lighter, brighter yellow to the mass tone and apply in a way to show the little curly petals. **Caution:** When adding your shadows and lighter, brighter colors, don't completely cover the mass tone. The lighter, brighter colors are: for yellow — Cadmium Yellow Medium, Cadmium Yellow Light and, when even lighter, add white; for orange — Cadmium Orange with Cadmium Yellow Medium mixed. If necessary, add white.

need for this project: *Thalo Red Rose, Alizarin Crimson, Thio Violet and Cobalt Violet.* You have to impart some of violet's complementary color to your tonal variations, especially in the mass tones and the shadows. If you don't, your bunches of lilacs will look raw and flat. Here's an example: add shadows on the bunches by adding more of the pure violet color and Burnt Umber (a complement to violet).

Add lighter values where the light strikes the bunches using a mixture of Thalo Red Rose and white. According to the lilacs that you're using as your models, adjust this color with a blue. For your mass tone: a slightly toned-down violet mixed with some Burnt Umber (or Raw Umber or Ivory Black) into your violet mass tone.

8. Marigolds

As in painting all flowers, arrange marigolds and paint them in all different directions — some from the side, some from the back, some facing you — so these various views work together to make a sensible presentation of the flowers.

1. Start by putting in a mass tone for the flower: for yellow marigolds — Cadmium Yellow Medium and Raw Sienna; for orange marigolds — Cadmium Orange and Burnt Sienna. Now, start with the flowers, making them bigger than they are so the background can cut into the flowers.

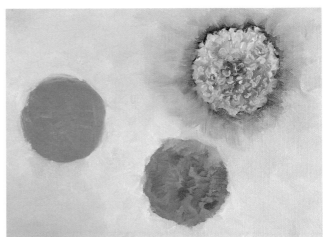

LES

8. Marigolds

9. Petunias — Red & Pink

These colors won't be too hard to characterize if they appear against a light background. Set the light background in first, stroking some of

9. Petunias

10. Poinsettias

If you paint a flower that's associated closely with a season of the year (poinsettias at Christmas and lilies at Easter) or with a geographic area (camellias, magnolias and cactus blossoms, come to mind) you must realize that your picture will have a limited appeal to those who view it. In order to have these subjects weather all the seasons, they must be exquisite paintings rather than just records of the flowers.

Even gladioli, which are identified with the arrangements of professional florists, can be considered a specialized kind of flower. Knowing all of this still doesn't keep us from trying to capture in paint the appeal of the aforementioned flowers. Here goes. Let's paint poinsettias.

1. Since poinsettia leaves are dark, and the red of the flower is dark in value, a poinsettia plant has to be painted against a light background or a background that's even darker than the tone of the leaves. Whichever background you choose, it seems more practical to paint your background area first, cutting it into your drawing of the plant.

2. First paint all the leaves that are positioned in such a way that other leaves overlap them. Remember — careful progression of application can make the painting process easier for you.

3. Some mixtures for green leaves:
1) Yellow Ochre, Thalo Green and a touch of white; 2) Cadmium Orange and Thalo Green; 3) Cadmium Yellow Light and Payne's Gray; 4) Thalo Green, Burnt Sienna and white; 5) Thalo Green, Burnt Umber and a little white. Any of these mixtures will give you a natural-looking green. And if any of these mixtures look a little bright, add a touch of Grumbacher Red to tone the green down.

4. Now for the leaves that have turned red and have seemingly made a flower. Again, first paint the leaves that are overlapped by the others. Use a mixture of Grumbacher Red with

the background color into the petunia's edge. Later on, you can chisel in the more dominant petunia color back over the background color that you have encroached into the outline.

Very important: make the mass tone color clean, vibrant and strong. Here are the mixtures:

Red Petunias: mix Alizarin Crimson and Grumbacher Red. Or use Grumbacher Red with Thalo Red Rose. Or — another choice — Alizarin Crimson and a touch of Cadmium Red Light. *Please, please — don't use Cadmium Red Medium or Cadmium Red Deep.* These two will make a dull flower.

Pink Petunias: the same mixtures as the red ones but add a little white and go lighter on the Alizarin Crimson.

Now we want to make these flower silhouettes look dimensional. Use pure Grumbacher Red and add lighter areas that you see for the red; add white and Grumbacher Red for the pink.

Finally, shadowing the two petunias: for the red petunia — Grumbacher Red, Alizarin Crimson, and add a little bit of Thalo Green. For the pink petunia — add more Alizarin Crimson and Grumbacher Red to the basic tone and add a little Viridian.

10. Poinsettias

Cadmium Red Light. Any darker toned red you see, use Alizarin Crimson with Grumbacher Red, and shadow the leaves by adding just a touch of green to the mixture.

Application hint: Stroke on the paint from the outline to the inner vein of the leaf rather than stroking outward from where the leaf is attached to the stem. This will give you the look of veins without having to paint the veins. Another hint: A way to paint a successful poinsettia picture is to paint a lot of flowers, letting them reach out of the top and the sides of the canvas so your picture is a massive design of red against a light background with some accents of green leaves.

11. Poppies — Red

Here's an important bit of advice for you to follow when painting any tubular-stemmed flowers such as poppies, zinnias, tulips and others: submerge their stems in water for thirty minutes to fill the stems with water. After that time, arrange your flowers but don't start painting them until about an hour later. With this chance to settle, the flowers won't move while you're painting them.

The characteristics of poppies are: 1. the paper thinness and 2. the little accordion-like ridges of the petals. In order to get the thinness, pay close attention to the reflections which mostly depend upon your background color. For

the "accordion pleats," use a soft Bright brush (red sable, sabeline or synthetic) that has been loaded with a color lighter than the mass tone and pile this color in little lines of paint onto the petals. You just can't get this look of fragility by adding dark lines. Here's the procedure:

1. In a general tone made of Grumbacher Red, a touch of Cadmium Red Light, a bit of white and a whisper of Chromium Oxide Green, mass in the flower shape. Start your stroke from the inside of the shape and stroke toward the flower's outline.

2. With more white than you used in Step 1, mixed with Grumbacher Red and Cadmium Red Light, add the lights that you see on each petal. Start with the petal that's farthest back from your view. Loading another brush with the basic tone, have it available to repaint petals that are in front of the one to which you've just added lights. This is how you make them look like they overlap. Repeat this process as needed to the point that the last petal you paint is the one that's closest to your view.

3. With some darks of Alizarin Crimson, accent your flower. Good for this is a large, round soft brush.

4. Finally, the reflected color (very important): use either pure Cadmium Red Light or Grumbacher Red and Cadmium Orange, or, for another choice, Grumbacher Red and white. Gear the tone of this color to be darker than your lighter values but lighter than your mass tone.

11. Poppies

12. Roses

12. Roses

Students have trouble with roses because they want their paints to capture the characteristic dewy look of a red rose too soon. You've got to first paint the red rose then add the dewy look.

1. A little smaller than you want it to be when it's finished, mass in the silhouette of the rose. An ample amount of Alizarin Crimson spiced with a bit of Grumbacher Red is a good mass tone mixture.

2. Now you're going to make a mixture that's more than a small puddle. For this, mix some white into a lot of Grumbacher Red. With this lighter tone, pile it onto the wet, massed-in red flower. Paint with a fresh load of paint each petal that seems lighter.

3. Add darker tones: Alizarin Crimson with a hint of Thalo Green.

Ready for the dewy look? Here goes:

I suggest that you add the dew after the painted rose has been left to dry a bit, like overnight. Use Ivory Black and white for a gray that's a little lighter in value than in Step 2. Load a big, soft brush (1" wide) with this gray mixture, then, with a rag, wipe the brush in order to lightly stroke a whisper of gray over the petals of the flower. Not wiping your brush will give you a gray instead of a light hazy, dewy look to the rose.

13. Tulips — Red

Compared to the front view of tulips, the one that makes you look into the bowl, the side view is easy. In painting this difficult view, the common mistake is to paint the lighter yellow color that is seen in the bowl too light. This makes the tulip you paint look flat instead of dimensional. Use Raw Sienna for the lighter yellow; it will keep that yellow in its place. And paint the Raw Sienna color first.

Here's some help: For flowers that are made up of two colors, always paint the more fragile color first or else the stronger color will certainly take it over. Even though this procedure seems to be so very logical, I'm mentioning it because I just know that there are students who, if not instructed, will do it otherwise.

The red of the tulip: For the mass tone, use Alizarin Crimson and a little Grumbacher Red.
For the lighter reds: Grumbacher Red and a little white.

For the darks: A little Thalo Green into a lot of Alizarin Crimson.

The shine, or gray highlight, is made with white, a touch of Ivory Black and a hint of Viridian.

Some more help: Each tulip petal has a spine in the middle. Adding your lighter and darker

13. Tulips

tones to your mass tone should enable you to record this well-known feature of the tulip's construction. Look for the important characteristics; you can't paint these effects if you don't see them.

LDG

14. Water Lilies

14. Water Lilies

Since water lilies show up in still ponds, you must first be able to paint water that looks calm and still before you can paint the water lilies that grow there.

After you've successfully painted the water, add the paint that will record the water lilies. Mass in the pattern of all the water lilies with a mixture of Thalo Green, Cadmium Orange and a little Burnt Sienna. You may have to adjust this value. Use white to lighten, black to gray or to darken. Mass in this color with little horizontal strokes. These brushstrokes will make the leaves look as though they're floating on the water.

Right under the lily pad add a touch of dark accent of Alizarin Crimson and Ivory Black into the leaf's color to show the little cast shadows or the underpart of the leaves. It's important to note that since the lilies are so close to the water, they won't reflect.

Now, with a mixture of Cadmium Red Light, Thalo Red Rose and a touch of white, plop the pretty blossoms on the leaves using short, vertical strokes to make them look like they're growing out of the leaves. Don't make

this initial pink color too light! Finally, lighten this mixture with more white and add some lighter tones to the blossom to show the light that's striking the blossom.

15. Zinnias — Orange

1. With Burnt Sienna, mass in the silhouette of the flower; not too thickly. I can hear you now, saying, "It's too dark!" Believe me, it's not. In the end it's going to serve as the shadows.

2. With a mixture of Cadmium Yellow Light and Cadmium Red Light, start to form the petals.

3. To accentuate the zinnia's petals, use Cadmium Orange with just a little white.

4. Using a touch of Thalo Blue into Burnt Sienna, paint the colors of the blossom's center and then the shadow that's caused by the fullness of the center. Use this mixture, too, for accents in the shadow.

Something to remember: When painting flowers with multiple petals, such as zinnias, it's easier to paint the petals that are half-hidden from view first, overlapping gradually as the petals come toward your point of vision. You'll have to load and reload your brush for each petal since you'll be working from dark to light.

ED

15. Zinnias

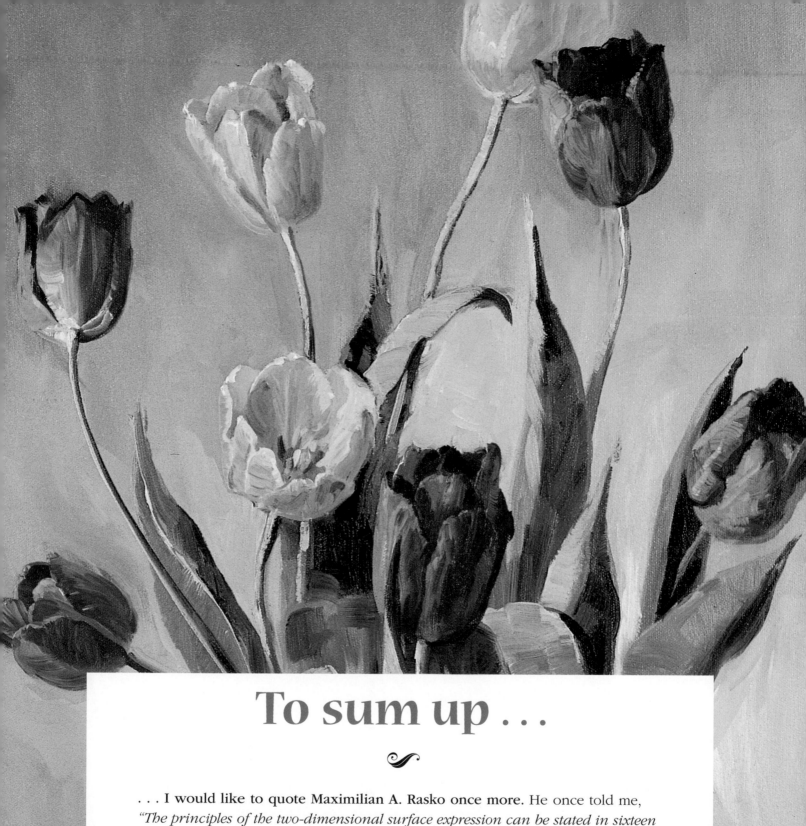

To sum up . . .

. . . I would like to quote Maximilian A. Rasko once more. He once told me, *"The principles of the two-dimensional surface expression can be stated in sixteen pages, no more and no less."* Rasko was a very definite man, and I believe his statement to be true. How, then, can the art of painting be a lifelong adventure? It can because only the **principles** of painting can be taught. The **art** of painting is a personal struggle. The quest of perfecting the painting process provides a lot of hours at the easel, and this very practice is one of the secrets to a degree of success. The information in this book is a reliable guide; the quality of your work I leave to you.

Index

Paintings by Helen Van Wyk

Helen Van Wyk Teaches on Video

Helen Van Wyk has been immortalized on videocassette, which you'll want to own to study over and over again in your home. Each video teaches a phase of the painting process that is a tribute to the teaching mastery of Helen Van Wyk. In each video, you will learn the techniques and procedures that have made Helen a favorite among students and art connoisseurs. While Helen tragically is no longer with us, her philosophy about art and painting instruction will live on forever. These videos present Helen in modes very much like those she exhibits in her nationally known television show, WELCOME TO MY STUDIO, except in each video, she enjoys the luxury of extra time, and can embellish her instruction.

Brush Techniques: Your Painting's Handwriting

Universally recognized as the most important tool in painting, the brush remains a mystery in the hand of a painting beginner as well as in more experienced hands. In this one-hour video, Helen demonstrates how versatile brushes can be when used properly. First, she guides the viewer towards using the right brush for the right job, then moves into the area of achieving different textures and effects to benefit each painting you do. Helen's instruction includes the all-important proper way to clean your brushes, a successful departure from the method that has been taught in art schools over many decades. Every artist should own a copy.

Painting Children from Photographs

Everyone wants to paint children but can't make them sit still. After years and years of painting children, Helen says, "never make them pose for you. Just photograph the little darlings." This video shows you how to go about it. Helen tells you what kind of photographs are best suited to use as models. And once you're set on one, she explains, in easy-to-understand instructions, how to transfer it to canvas through the grid method. There's much more in this one-hour presentation: preparing an underpainting, applying glazes and also the technique of *alla prima* (direct) painting. At last, you can paint the child in your life without fuss and stress.

Elegant Abundance

During the 16th and 17th centuries, Dutch still life painters were producing masterpieces that were emblematic of the so-called Age of Elegance. In this 90-minute video, Helen recaptures that era with her superb still life that bursts with subjects and textures: lemons, silver, lobsters, glass, flowers, and more. Hence, the word "abundance" in the title. If still life is your painting passion, you absolutely have to own this stunning vehicle of instruction. It will help you, too, with other facets of your painting production. As Helen had always asserted, "still life is the backbone of good painting." This is the last video made by Helen Van Wyk.

Oil Painting Techniques and Procedures

A two-hour demonstration of a still life. It starts with a monochromatic underpainting and is followed by glazing applications to end with direct *alla prima* touches. Finally, the technique of glazing is fully explained and illustrated. In this still life, you will see Helen paint every kind of texture which will help you with all the subject matter you may encounter in your still lifes. In the composition there is a non-reflective jug, a transparent green glass bottle, a copper pitcher, apples, lemons (cut and whole), grapes, white tablecloth and the all-important background. It is safe to say that an entire painting course resides in this one video.

Painting Flowers *Alla Prima*

Alla prima is an Italian phrase that means "all at once." In this one-hour presentation, Helen demonstrates this direct application of paint to interpret a bouquet of daisies. Starting with four marks on the canvas, to indicate the outer reaches of her composition, she proceeds to build her painting, ending with the highlights. Throughout this video, you will learn how Helen gets her paint moist and juicy, a look that has entranced viewers of her TV show and live demonstrations. Helen Van Wyk is a fountain of information, never shying from dispensing it to all those interested in painting better.

A Portrait: Step-by-Step

One hour of painting a male model. In this video, Helen covers every facet of portrait painting, experience gained from fifty years of painting people. You will learn about mixing the right flesh color, getting the shadow to look just right, and that difficult "turning edge," the area between light and shadow. "Anyone can get a likeness," Helen says, "but the trick is to make the model look human." If portraits are your interest, you won't want to miss this sterling, informative video. Once in your possession, you'll find yourself watching it over and over. You will be amazed at how much it will help you with your portraits.